KU-693-862

KU-693-862

HOB £ 3.50
17/24 01

THE SIMPLE ART OF Chinese Calligraphy

THE SIMPLE ART OF Chinese Calligraphy

Qu Lei Lei

Create your own Chinese characters and symbols for good fortune and prosperity

CICO BOOKS
London

First published in 2002 by Cico Books Ltd
32 Great Sutton Street London EC1V 0NB

Copyright © Cico Books 2002
Project designs © Qu Lei Lei 2002

The right of Qu Lei Lei to be identified as author of this text has been
asserted by him in accordance with the Copyright, Designs and Patents Act
of 1988.

All rights reserved. No part of this publication may be reproduced, stored
in or introduced into a retrieval system, or transmitted in any form or by
any means, electronic, mechanical, photocopying, recording or otherwise,
without the prior written permission of the copyright holder and publisher.

10 9 8 7 6 5 4 3 2 1

A CIP catalogue record for this book is available from the British Library

ISBN 1 903116 49 X

Edited by Liz Dean
Photography by Geoff Dann
Styling by Denise Brock
Designed by Roger Daniels

Printed and bound in Singapore

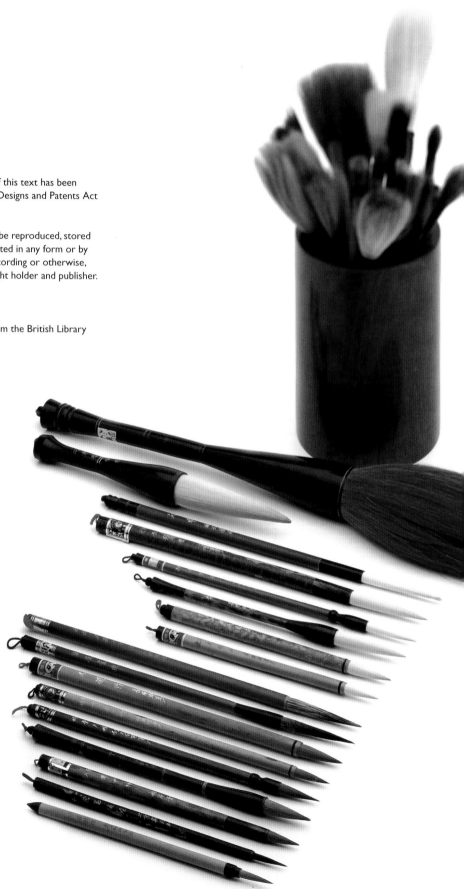

c o n t e n t s

introduction

Chinese calligraphy is the term given to the art form of the creation and writing of some of the world's oldest symbols, Chinese characters.

Chinese script is one of the oldest forms of writing in existence. In BCE 4000, the ancestors of today's Chinese people created marks recording their lives and labors in relationship to the natural world, which were then carved or fired into pottery. Composed of linear patterns, these carvings are the earliest examples of embryonic pictograms to express abstract thoughts. Over the following thousands of years, a great variety of fascinating Chinese characters and styles has evolved and, simultaneously, follows the art of calligraphy.

In recent times, alongside a more scientific world-view, there have been many attempts by the Chinese state to modernize or reform Chinese characters and even Romanize them to European-style script. However, these attempts have never fully succeeded, because Chinese characters themselves represent not merely words but the culture, art, and history of China as well. There is a widespread consensus in China today that it is better to retain and develop the existing traditional culture and script.

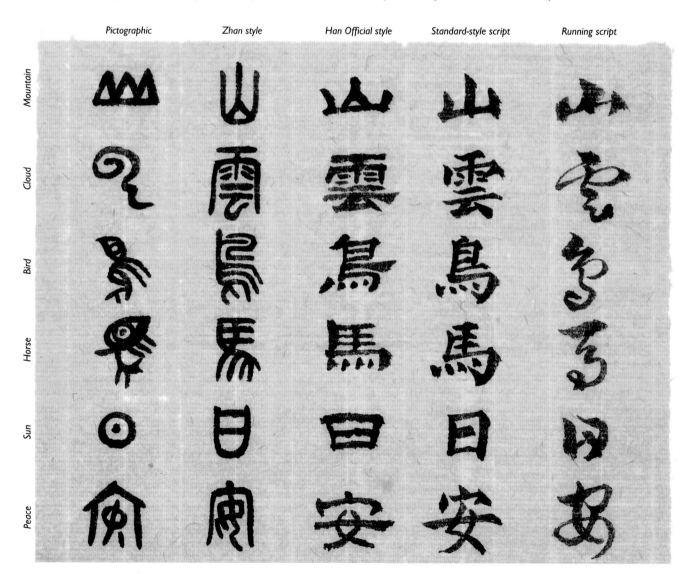

The development of the Chinese character from its earliest form as a pictogram, or literal representation, to the abstract sophistication of Running script.

Calligraphy was the most highly-prized of oriental art forms; in ancient China, it was impossible to pass a civic exam for a Government post if you could not create calligraphy proficiently. Throughout the history of the East, great intellectuals, painters, writers, poets, and doctors, were often also great calligraphers. The famous saying in China, "Chinese characters reflect the man", explains the long-held Chinese belief that just a single page of calligraphy reveals the secrets of its writer's character.

The study of Chinese calligraphy is an excellent means of self development and achieving inner harmony. Central to Chinese culture through the ages is the ancient Daoist concept of Qi, the belief that in order to fully express true inner feelings and spiritual insights it is necessary to attain a balanced combination of correct breathing, good circulation, and mental and physical activities. Through the centuries, a traditional way to to achieve the state of spiritual content is through the art and regular practice of calligraphy.

As we quiet the heart and clear the mind, while grinding a pool of

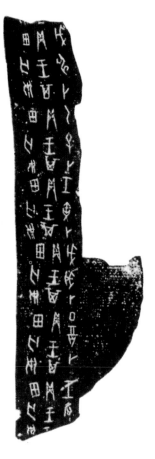
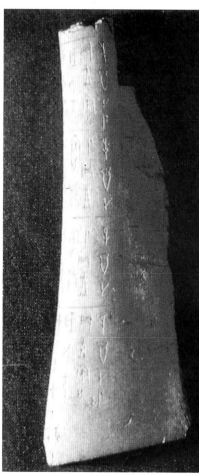

Fragments of black and natural bone shell, remnants from around BCE 1500, show the typical vertical writing lines of calligraphy writing in this Bone Shell script.

fragrant ink, sitting upright with a straight spine and breathing smoothly and deeply, we can express our hearts entirely through the soft tip of the brush and steep our hearts to overflowing in this ancient heritage. Once you are used to the practice, you may be able to feel and express your innermost feelings through this art form. In place of the frenzy, noise, and pressures of modern life, you will begin to achieve tranquility, harmony, and balance, and you will benefit both mentally and physically.

Beginning with a comprehensive introduction to the illustrious history of Chinese calligraphy, we then introduce you to the "scholar objects", or materials, which will become your best friends for life. We then concentrate on the foundation for your study and practice, showing you how to learn and use the Standard-style script, Kai Shu, of calligraphy so we can work together on uses for calligraphy, creating greeting cards, everyday crafts, and signing your name. "Take a slow boat to China; everything will be very well". I hope this book will be a little boat taking you to that far, strange and enigmatic place.

Early rock carvings from prehistoric China show the first human attempts to capture abstract ideas about the natural landscape.

h i s t o r y

Calligraphy is one of the oldest arts in civilization, having developed over the past six thousand years. Its history and progress are closely linked to the very beginnings of human writing and the variety and richness of the Chinese alphabet, itself created through centuries of cultural and political activity. The history of calligraphy can seem complex, but as you progress you will see that the characters and history are inextricably linked, and many of the projects in this book have historical roots.

Chinese characters themselves have developed throughout the ages from pictograms, miniature representations of objects, with each character becoming more abstract and sophisticated (see page 6 for a chart of the development of a typical character).

The first examples of decorative writing, or calligraphy as art, date from the Shang dynasty (c. BCE 1700–1050). Known as Bone Shell script (see page 7), characters were cut into tortoise-shells or animal bones to record ceremonial events. Individual strokes are straight, and there is no rigid form to their structure, size, and composition. As the Shang dynasty progressed, the Bronze Age emerged, characterized by a profusion of bronze domestic objects, which gave their name to the script. Among them were the *zhong* (bell) and *ding*

Right: Dating from the Bronze Age, this fine serving pot features carved calligraphic poetry (see detail at base), in a script, Zhong Ding, named after the domestic objects themselves.

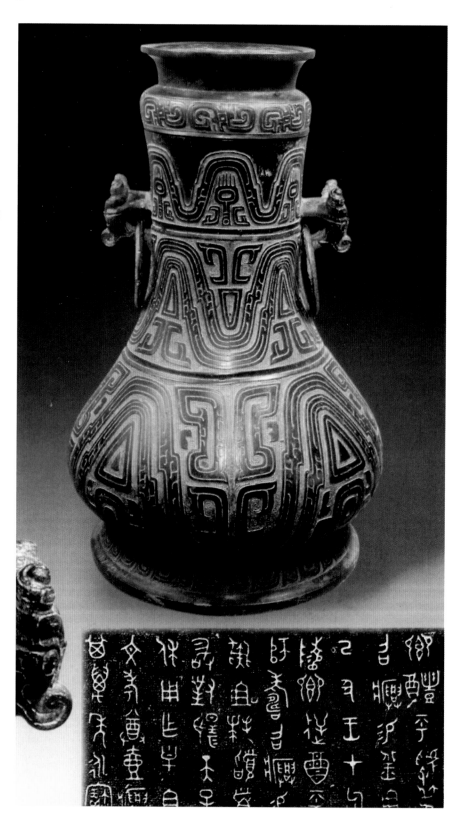

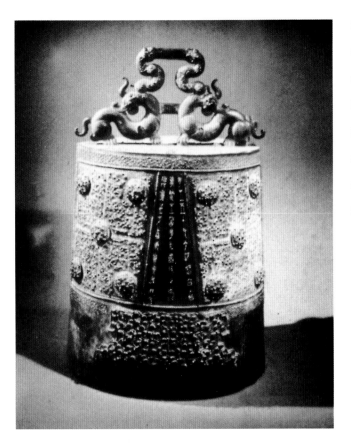

(cooking pot), on which marks were carved or cast. The creation of bronze artifacts reached its peak in BCE 1050–221, when Zhong Ding became the major calligraphic form. The period marked the beginning of systemized calligraphy, including many practices, such as composition techniques, that are still in use today. In BCE 750, senior Government historian Zhou created the *Shi Zhou Pian*, 15 calligraphy text books, which formed Zhou script. The earliest known examples were carved during the Warrior Period (BCE 457–221) (see below).

Above: This ceremonial bell, or *zhong*, is cast from from bronze.

Above right: A detail from the bell above, this is a transcription of the calligraphy on the bell, known as the Zhong Ding script.

Right and far right: One of the key artifacts in the history of calligraphy, this stone drum to the far right is the finest remaining example of calligraphy carved in the Warrior Period. The detail to its left is a stone rubbing of early Zhou script.

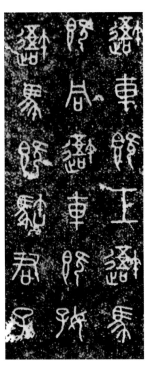

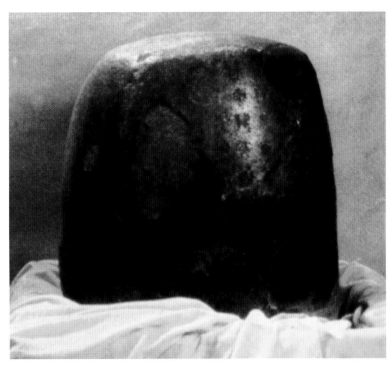

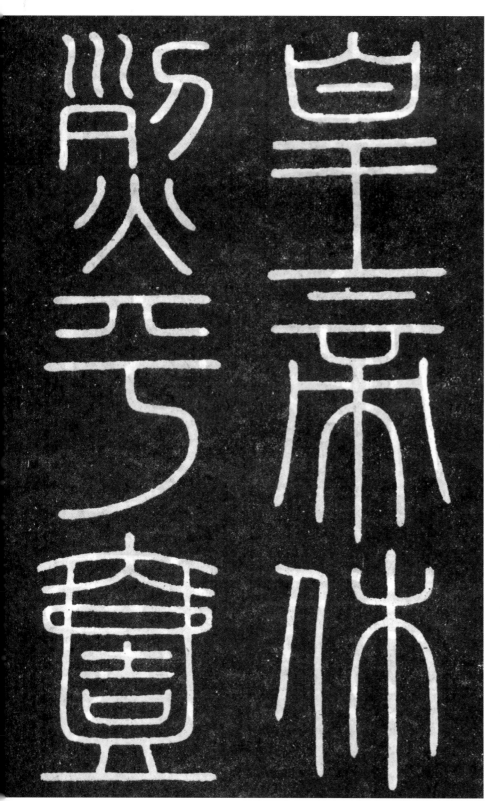

BCE 221 saw the unification of all China under the great emperor Qin Shi Huang Di, who also standardized China's currency, language, and script. His Prime Minister, Li Si, created a standard script for offical use, known as Small Zhuan style. All Small Zhuan characters are a similar size; the overall shape is a tall rectangle, with most elements in the upper part of the character. The strokes are a constant thickness – slender but forceful, straight, tall, smooth, and flowing. Although slow to write, this beautiful, austere style remains the most popular for seal carving, and is thus also known as Seal script.

During the Han dynasty (BCE 206–CE 220) China's economy grew. A unique script was developed for state business. This was a simplified form of Small Zhuan, known as Han Official. As it evolved, the pictographic, or purely representative element (see page 6) became less pronounced, but the strokes themselves grew in importance; curves became squarer. Chinese script development reached a turning point: for the first time the amount of pressure applied to the brush varied. Strokes were made by pressing down on the brush at the beginning of the stroke then gradually lifting it off at the end. Other forms of calligraphy flourished: masterpieces of calligraphy were

Left: Seal script, or Small Zhuan, created over 2,000 years ago, is still the popular choice for carving the clear, crisp characters of stone seals.

created by carving landscape rocks and cliff faces. As paper only came to China early during this period, books were created from bamboo or wooden strips (see page 82) joined by leather cord. "Wei bian san yue" is a famous phrase from this period, describing someone who has studied so diligently that he has had to replace the broken cords of his book three times.

The prevalence of war during the later Eastern Han Period (CE 25–220) created the necessity to circulate information fast; this gave rise to a very swift form of writing, with fewer and simplified rules, but retaining the wave-like nature of the horizontal stroke. Named the Zhang Cao, Zhang Running script, or Freehand, Zhang Zhi (d. CE 192) developed this method, which linked the strokes together, so that most characters could be created in a single stroke. His work formed the basis of the Jin Cao, or Contemporary Running script, which is still used today. Nearly two millennia later, Zhang Zhi is still refered to by calligraphers as the saint of Running script.

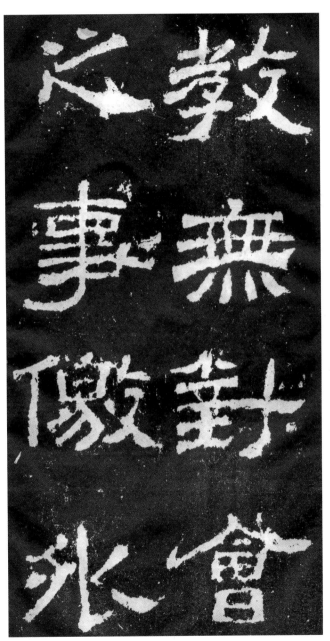

Above: This stone rubbing of carved calligraphy dates from the Han Dynasty. It shows the Governmental script, Han Official script, which was used for all state correspondence.

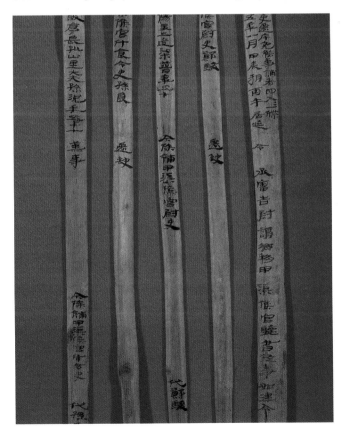

Left: The earliest books in human history, bound bamboo strips with calligraphy written vertically on each strip, dominated until the Han Dynasty when silk and paper, in the later Han period, took over as writing materials.

Zhong You (CE 151–230), tutor to Emperor Wei Ming Di, is known as the Ancestor of Standard-style script. Working in Han Official style (see below, far right), he created almost square characters that are slightly broader than their height. Strokes are straight without waving — the key variation that established the start of Standard-style script (Kai Shu), the most popular form today.

When the Han Dynasty ended, China broke up. Internal turmoil for over three centuries characterized the Wei Jin Six Dynasty period (CE 220–580). Disillusioned, many intellectuals turned away from politics, channeling their talents and emotions into literature and art. Ironically, civil unrest led to tremendous artistic progress; and produced the greatest figure in the history of calligraphy. The great master, Wang Xi Zhi (CE 321–379) was unsurpassed in every style, and his work has dominated Chinese calligraphy ever since. Innovations in stone carving also took place. Stonemasons carved from the hand-written texts of the master calligraphers.

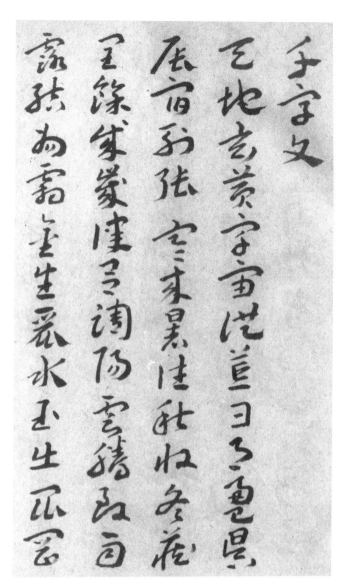

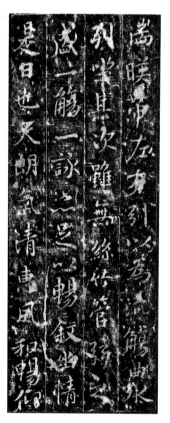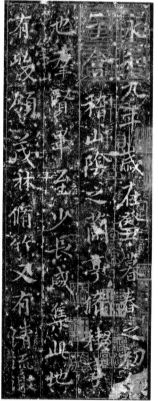

Above: Zhang Cao, or Zhang Running script, was created and used from CE 150, during the Han Dynasty.

Left: Created by the Ancestor of Standard-style script, this piece is the work of Zhong You (CE 151–230).

Far left and center: Both these examples of Standard script were created by the greatest master of calligraphy, Wang Xi Zhi (CE 321–379). His many innovations in calligraphy and carving have dominated the art since that period.

Working in the early 4th century was a second master, Zheng Dao Zhao. Establishing another genesis of Standard-style script, his calligraphy reveals the historic link between Han Official and Standard-style script. Moving the brush at speed from beginning to end, the dots and strokes are forceful and incisive. The side of the tip of the brush was often used for curves to create a sharp edge, hooks and ticks are formed with great power, and aside and right falling strokes are executed with firm pressure.

The golden age of Chinese calligraphy took place in the Tang dynasty (CE 618–907). During this time, Standard-style script reached its zenith and all other styles reached the form in which they are used today. The epoch is marked by the sheer number of great artists who offer inspiration to calligraphers today. Early practitioners include Ou Yan Xun (CE 557–641), Yu Shi Nan (CE 558–638), Chu Sui Liang (CE 596–658), and Sun Guo Ting (CE 648–703). Chief among the masters are Yan Zhen Qing (CE 709–785) and Liu Gong Quan (CE 778–865) who gave their names to the finest variations of Standard-style script. Both Yan and Liu forms are imposing and vigorous, yet restrained; Yan characters are broad, while Liu characters are slender (see page 35).

Right: This vigorous, jagged calligraphy, the work of Zheng Dao Zhao, shows the development of calligraphy from early Han Official style to its modern Standard-style script.

Left: A fine example from the golden age of Chinese calligraphy, this piece was created by Chu Sui Liang (CE 596–658).

The Yan and Liu forms of Standard-style script, Kai Shu, continue to bear enormous influence even today, not least as essential practice examples and samples for the new student. Liu Gong Quan also provided key advice for the aspiring calligrapher with his maxim: "A centered and upright heart makes for an assiduous and upright brush."

Great calligraphers of Running script, then referred to as Freehand or Cursive (Cao Shu) style, also dominated the Tang dynasty. The calligraphy of both Zhang Xu (c. CE 7th–8th century) and Huai Su (CE 725–785) shows an unbridled energy of free expression. However, in the true manner of a master calligrapher, while their work has the "expressiveness of madness, the freedom of flight, and the velocity and power of lightning", both artists always followed the rules established in the Wei Jin period some 400 years previously. They continue to hold great influence on Running script calligraphers.

In CE 906, civil war broke out and for the fifty years of the Five Dynasties (CE 907–960) China was fragmented once again. Reunited in the Song dynasty (CE 960–1270), a newly benign climate, defined by calligrapher Chong Wen Yi Wu as "respect of culture and control of the military", emerged as a fertile period for calligraphy. From the emperor to the middle-class , the arts were now the nation's favorite pastime. Correspondingly, the artistic purpose of calligraphy shifted: the main emphasis now was on enjoyment and the cultivation of the soul. The Song dynasty saw calligraphy develop further as a spiritual discipline: the intellectuals of the period treated calligraphy as an expression of the heart.

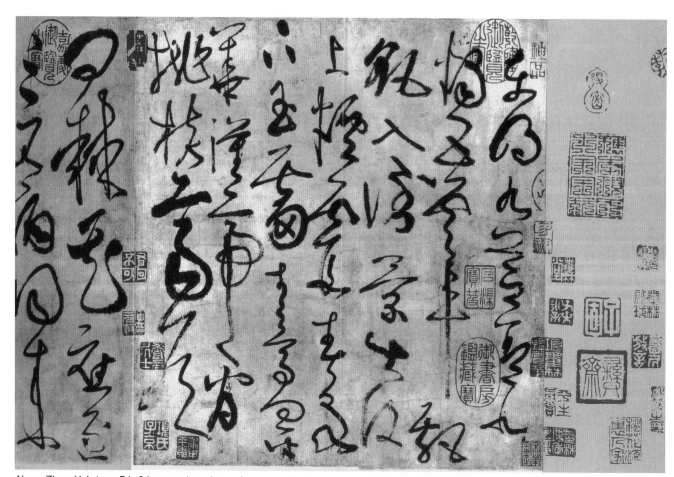

Above: Zhang Xu's (c. CE 7th–8th century) rendition of a poem in Running script reveals its energy and freedom without compromising strict rules of style.

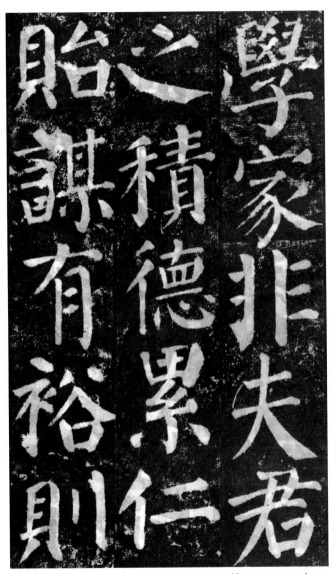

Above: dating from the Tang golden age, this stone rubbing was created from the work of Yan Zhen Qing and copied by a master stonemason.

As we can see, the extraordinarily sophisticated major developments in calligraphy took place even before CE 1000, while the Dark Ages still had Europe in their grip. During the past 1000 years, through the Yuan (1279–1368), Ming (1368–1644), and Qing (1644–1911) dynasties, China has produced many great calligraphers who have followed in their masters' footsteps and created personal style variations. Masterpieces from these two milliennia are as abundant as stars in the sky, examples of which can be found in museums, galleries, private collections, and art markets throughout the world.

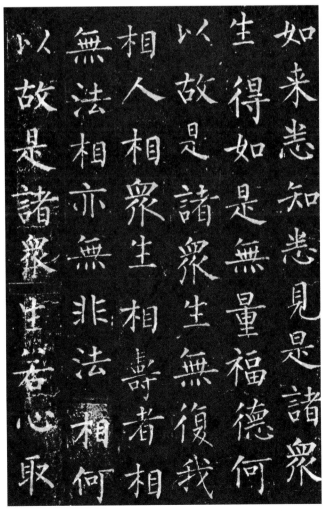

Above: The Standard-style script of Liu Gong Quan (CE 778–865) (see page 34).

Artists and intellectuals sought a form that would capture the intensity of their feelings and aspirations, and the idea of a combination of techniques evolved. The great Chinese tradition of The Three Perfections began; the use of poetry, painting, and calligraphy in a single artwork. Still dominant today, this intellectual and beautiful art form continues to hold sway as the major tradition in contemporary Chinese art. Of special note are Su Dong Po (1037–1101), Huang Ting Jian (1045–1105) and Mi Fu (1051–1107).

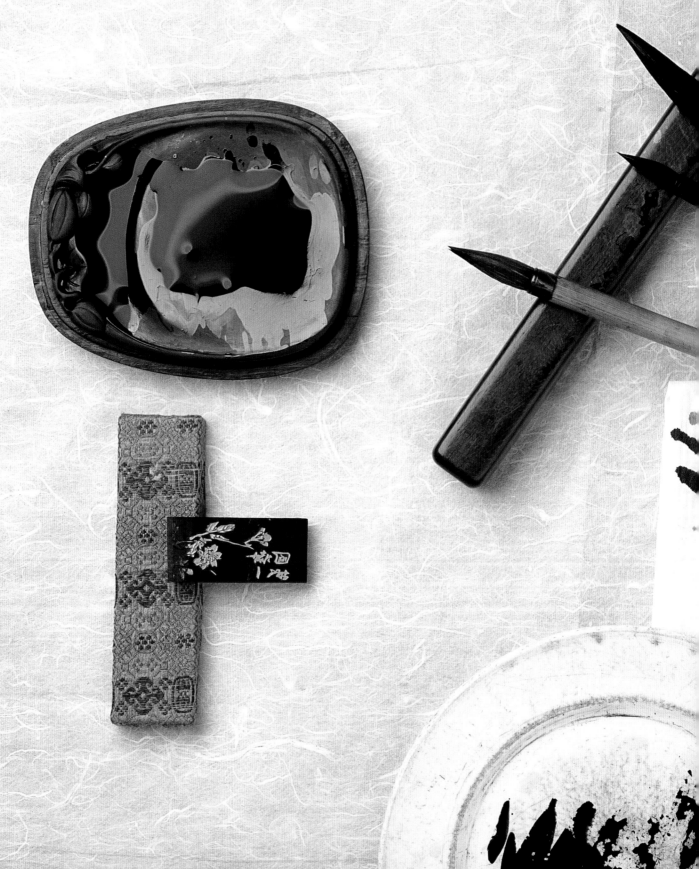

the four
treasures:
materials

The "scholar objects", or materials, of calligraphy: ink, brush, ink stone, and paper, have been known in China for thousands of years as The Four Treasures. The illustrious title hints at their importance in the history and culture of brush writing, with celebrated calligraphers developing a ritual of laying out the materials in set positions, and using the preparation as a time to meditate on the work to come. Each of the four pieces has been developed through the centuries: even today, new inks and papers are being created.

永

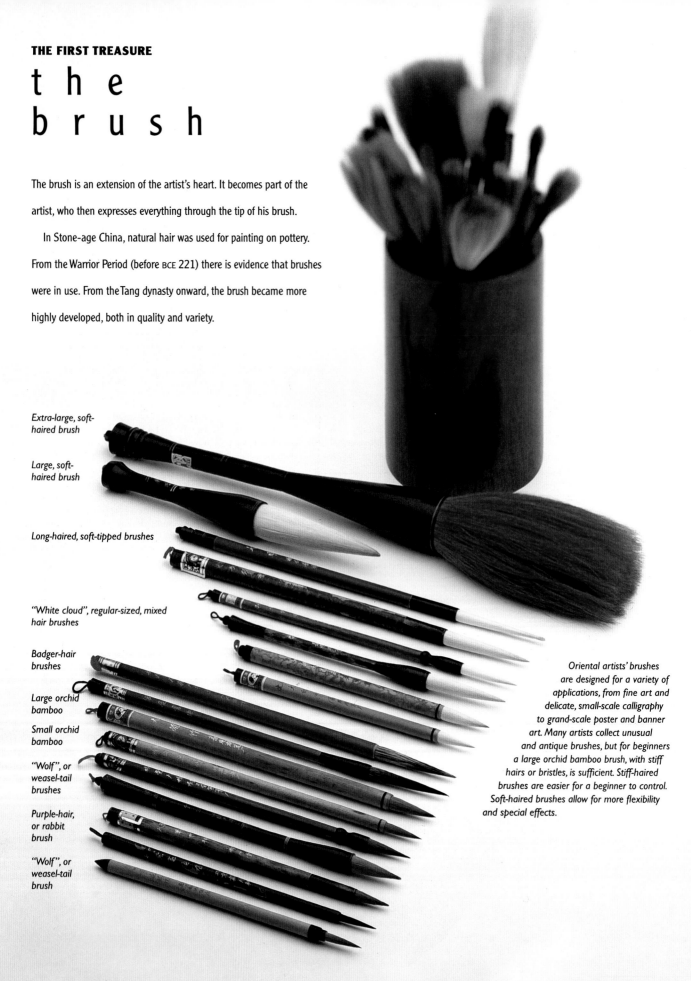

THE FIRST TREASURE
the brush

The brush is an extension of the artist's heart. It becomes part of the artist, who then expresses everything through the tip of his brush.

In Stone-age China, natural hair was used for painting on pottery. From the Warrior Period (before BCE 221) there is evidence that brushes were in use. From the Tang dynasty onward, the brush became more highly developed, both in quality and variety.

Extra-large, soft-haired brush

Large, soft-haired brush

Long-haired, soft-tipped brushes

"White cloud", regular-sized, mixed hair brushes

Badger-hair brushes

Large orchid bamboo

Small orchid bamboo

"Wolf", or weasel-tail brushes

Purple-hair, or rabbit brush

"Wolf", or weasel-tail brush

Oriental artists' brushes are designed for a variety of applications, from fine art and delicate, small-scale calligraphy to grand-scale poster and banner art. Many artists collect unusual and antique brushes, but for beginners a large orchid bamboo brush, with stiff hairs or bristles, is sufficient. Stiff-haired brushes are easier for a beginner to control. Soft-haired brushes allow for more flexibility and special effects.

Brush types

Brushes are defined by the characteristics of the hairs and fall into three categories: stiff, soft, and mixed. Within these general categories are hundreds of different brushes varying in size, shape, and length of tip, made for many different purposes.

Stiff-hair brushes are known as wolf-hair brushes, but they are usually made of weasel hair. Other stiff brushes are commonly made from horse hair, badger, or rabbit hair. Soft-hair brushes are made from goat hair. Although the beginner may find the stiff-hair brush easier to control, the soft-hair brush has greater flexibility and enables the more experienced artist to create a greater variety of effects. Mixed stiff- and soft-hair brushes have the advantages of both types, and they can be used for a wide range of painting and calligraphic styles.

A brush with stiff hair and a sharp tip is the most suitable choice for small-scale calligraphy. Cursive styles of calligraphy, incorporating unexpected effects, require a soft-hair brush.

Begin your practice with an orchid bamboo brush. Use a large brush, even for executing small-scale calligraphy. A small brush should never be used for large-scale calligraphy.

CHOOSING A BRUSH

The traditional artist uses the following four criteria for judging the quality of a brush before purchase and use:

1 Sharpness (jian)

The hairs, or bristles, on the brush should always form a defined, symmetrical tip.

2 Evenness (qi)

When the brush is dry, the hairs should be level and even, tapering to exactly the same length. (Note, however, that the hair length for some specialist brushes varies, and therefore they are an exception to this rule).

3 Roundness (yuan)

The body of the brush formed by the hairs should be round and plump, so that the brush retains the same shape from every angle. Turn the brush around to check this before you buy.

4 Resilience (jian)

A good brush should have hairs that are springy and resilient, and have a good "spine" or "waist" (this is the area at the base of the tip). When the brush is wet, the brush should retain its shape after being pressed down on paper.

Brush handles

Brush handles are most frequently made of bamboo, but they may also be made of ceramic. The part of the handle into which the hairs are inserted is sometimes made from buffalo horn.

Whatever material they are fashioned from, brush handles should always be perfectly straight.

Caring for brushes

The hairs of most new brushes are coated with a water-soluble glue after manufacture. This acts as a temporary seal which protects the brush hairs from damage before use. Before you use a new brush, the water-soluble glue should be removed by soaking the brush in clean, cold water for as long as necessary. This may take around twenty minutes for a small brush, so expect larger brushes to take much longer. When all the glue has dissolved, remove the brush and dry it using a tissue.

Some new brushes come with a protective plastic or bamboo cover. This should be discarded after purchase – do not put it back over the hairs once the brush has been soaked to remove the glue.

Always clean your brushes in clean, cold water immediately after use. Do not allow any ink to remain on the brush, because this will dry and harden the hairs, and prevent them retaining fresh ink when you next use the brush. This greatly diminishes its effectiveness, and you may need to discard the brush all together if this happens.

All brushes have a small loop at the base of the handle. This is for suspending the brush so it can dry thoroughly after use. Hang your brush upside down in a cool, dry place so that air can circulate freely around the hairs. Once the brush is dry, place it upright in a brush pot ready for its next use.

If you need to transport your brushes at any time, wrapping them in a bamboo roll (available from specialist Chinese art stores) keeps them safe and dry while you are traveling.

THE SECOND TREASURE
i n k

Ink and brush are looked on as twins, as they always work together, and are valued greatly as an integral part of a scholar's life. Ink is treated very seriously, as it is the means by which a work of art is manifested. There is a saying that it is easier to obtain gold than good ink!

Since the Tang dynasty, ink has been highly developed, and every dynasty has had its famous ink makers. As the quality and variety of ink improved over the years, the manufacture of ink became an art form in itself, with quality ink sticks considered highly collectable by scholars.

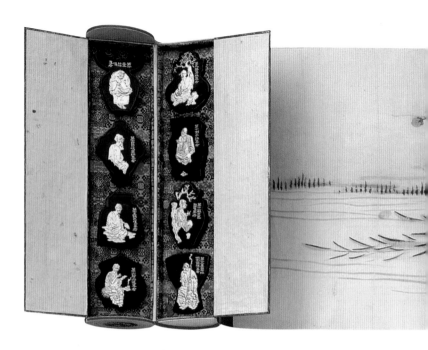

An oil soot stick (right)

Commemorative charcoal soot ink sticks made during China's Cultural Revolution

TYPES OF INK

The main ingredients of a proper ink stick are soot mixed with glue, together with a preservative and fragrance. Ten or more other ingredients may be added. Some may even include very exotic ingredients, such as pearl, gold, musk, or snake bile.

The type of soot used defines an ink. The soot is derived from pine, oil, or industrial charcoal. Different amounts of glue are mixed with each type of soot, depending on the particular purpose of the ink.

Ink from oil soot gives a warm black color, and during manufacture it is combined with more glue than the other types. This combination makes a good general-purpose ink.

Pine soot ink is a cooler, blue-black, and is combined with less glue and oil. It is good for calligraphy and meticulous style painting.

Ink made from industrial charcoal soot has the least amount of glue and oil. It spreads more readily, and is suitable for freehand calligraphy.

There are no definite rules as to which type of ink should be used in any particular instance, but

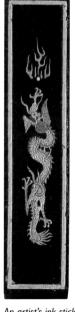

An artist's ink stick.

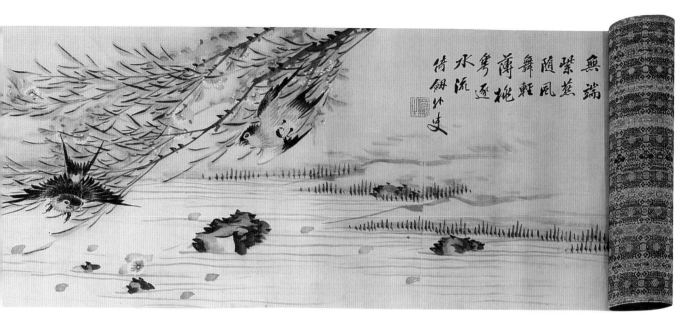

An ink stick set from 1840, with 16 holy monks in ink, painted by 5th-dynasty-artist Guan Xu accompanied by a watercolor landscape (above).

Colored ink sticks (left)

with practice you will experience the different effects that can be achieved.

APPLICATIONS

Artistic ink is for general painting and calligraphy. This type of ink usually has a modest appearance, but is of good quality.

Custom-made Famous artists may commission ink to be made with particular qualities, to their own design and recipe. Often this type of ink becomes the renowned product of the ink maker.

Collectors' inks These inks may be created specifically as gifts, or to commemorate special events. As they are made only for collecting, their appearance is usually very beautiful and ornate, but the type of ink used is not necessarily of the highest quality.

Colored ink sticks These are made of natural pigments and are used for painting and calligraphy. For example, in Imperial China, the Emperor would have used a cinnabai-colored ink stick to write the calligraphy of official decrees.

Medical ink This is a very specific, non-poisonous ink that is ground and taken internally as a remedy. It can also be used for calligraphy.

CHOOSING INK

A good-quality ink should have the following properties: it should be as solid as stone (*jain ru shi*), have a texture like rhino horn (*wen ru xi*), and be black as lacquer (*hei ru qi*).

When the inner grinding surface of ink catches the light, it should have a purple-blue sheen. A black sheen denotes ink of a lesser quality, and a white sheen indicates a poor-quality ink. A good ink has a pleasant, fragrant smell, and is said to have edges sharp enough to cut paper.

Modern manufactured liquid ink is available in various qualities.

All good-quality inks, once they have dried, should not spread when the paper is wetted for mounting, and they should retain their freshness for eternity.

An artist's good-quality ink stick made of pure pine soot.

THE THIRD TREASURE

p a p e r

In the way that the brush is an extension of the artist's heart, paper is the vehicle of the artist's heart blood.

Paper was in existence in the Han dynasty (BCE 206). Before that time, books in China were made of bamboo and wood strips. As with the first two Treasures, the brush and ink, paper manufacture became highly developed from the Tang dynasty onwards. Of particular note is Xuan paper (incorrectly called rice paper), which is made from green sandalwood bark and other materials. For more than 1000 years it has been world famous for its use in Chinese painting and calligraphy.

Calligraphy paper varies in size, texture and absorbency, but any surface that holds ink adequately – even newsprint – is suitable for calligraphy. You can choose to work in small or large albums, on paper scrolls, sized silk, or with gold-flecked or colored papers.

Paper for letter-writing

Couplet paper

Xuan paper

PAPER TYPES

Of the different types of paper available today, Yuan shu and Mao bian paper are both good for calligraphy. Although sometimes referred to as grass paper, the major fibers of these papers are bamboo, straw, and bark. These types of paper are good for the beginner, as they are absorbent without causing the ink to spread too much.

There are three main paper finishes: unsized, or raw (*sheng xuan*); semi-sized (*ban shu*); and sized (*shu xuan*). These range respectively from very absorbent (unsized) to minimal absorbency (sized). Specially prepared painting silk (*juan*) can also be used, which is usually sized.

PAPER SIZES

Chinese painting paper comes in many sizes and thicknesses to cater for the equally diverse styles of painting and calligraphy. A common width and length ratio is 1:2, and sizes range from album leaves (the size of the palm of a hand) through to business-letter format and sheets that are as large as 12 x 6 ft (3.6 x 1.8 m). Square sheets are available, also in varying sizes, as are scrolls, which may be up to 164 ft (50 m) long.

A similarly wide variety is found in the thicknesses of paper. The most delicate is said to be as thin as a cicada's wing, whereas the thickest double- and treble-Xuan papers

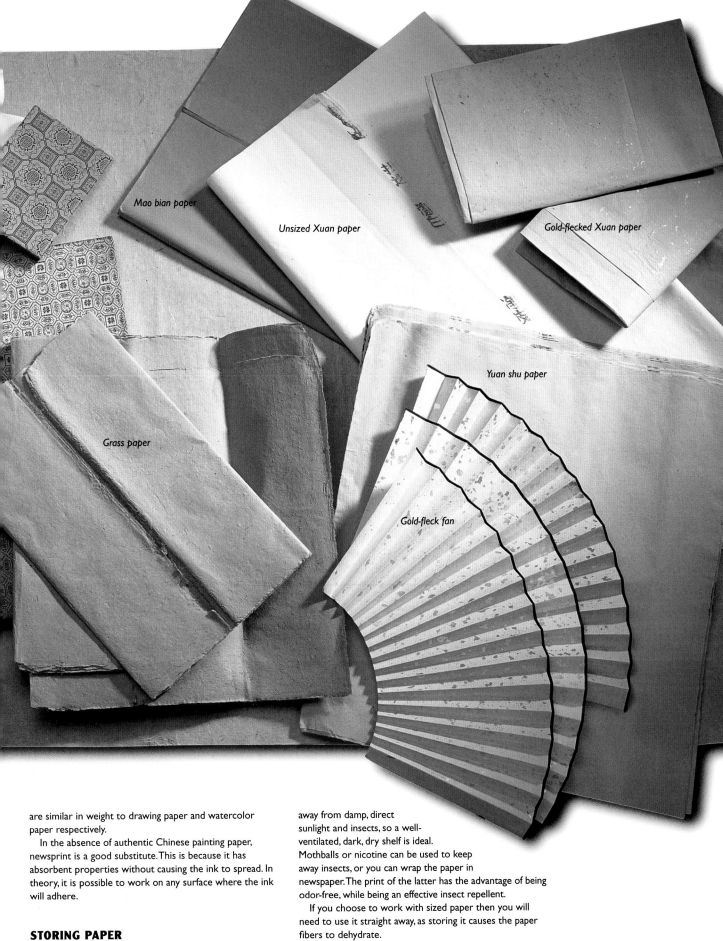

Mao bian paper

Unsized Xuan paper

Gold-flecked Xuan paper

Yuan shu paper

Grass paper

Gold-fleck fan

are similar in weight to drawing paper and watercolor paper respectively.

In the absence of authentic Chinese painting paper, newsprint is a good substitute. This is because it has absorbent properties without causing the ink to spread. In theory, it is possible to work on any surface where the ink will adhere.

STORING PAPER

The longer that unsized Xuan paper is kept, the easier it becomes to use. When storing this kind of paper, keep it away from damp, direct sunlight and insects, so a well-ventilated, dark, dry shelf is ideal. Mothballs or nicotine can be used to keep away insects, or you can wrap the paper in newspaper. The print of the latter has the advantage of being odor-free, while being an effective insect repellent.

If you choose to work with sized paper then you will need to use it straight away, as storing it causes the paper fibers to dehydrate.

THE FOURTH TREASURE
the ink stone

Scholars treasure their ink stone as if it were their best friend, who remains loyal for a whole lifetime. The collecting of ink stones may become a passion, with the collector owning hundreds of examples.

Qualities

The purpose of the ink stone is to grind the solid ink to produce a usable liquid for painting and calligraphy. A good ink stone is solid and smooth, and produces ink quickly without damaging the brush.

There are hundreds of different kinds of ink stones in China. Four of the most famous ink stones come from different parts of China. From Canton province comes the Duan stone; there is the She stone, which is found in An Hui and Jiang Xi provinces; and the Tao stone, which comes from Gan Su province. The fourth is made of pottery created from the mud of the Fen River, and is known as the Cheng Ni, or portrait ink grinder.

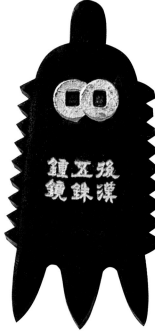

Left: *this collector's ink represents Shou Xing, the Chinese Immortal symbolizing longevity.*
Above: *souvenir ink sticks*

TYPES OF INK STONE

Ink stones are categorized in three ways:

Famous ink stones (Ming yan) have been owned and used by famous people, and have an antique value because of this. Quality may not be important.

Old ink stones (Gu yan) are those that have seen a lot of history, such as 2000 years!

Good ink stones (Jia yan) Can be new and must be well-shaped and carved. The quality is important for a Jia yan stone.

SELECTING AN INK STONE

When selecting an ink stone, the following points should be considered:

1 Quality (Zhi)

The stone must be solid, smooth as a baby's cheek, and produce a fine liquid quickly.

2 Shape (Pin)

Simple, regular shapes are preferable: square, rectangle, round, or oval. Others retaining the natural shape of the rock may have their own aesthetic appeal.

3 Workmanship (Gong)

The ink stone should be well designed and carved.

4 Inscription (Ming)

Usually the inscriptions carved on the ink stone record dates, owners, or historical events. This enhances the value for the collector, but beware of fakes!

5 Container

Ideally, an ink stone should have a wooden cover or be kept in a wooden box, usually lacquered, to protect the stone and to keep the ink in use from drying out. The wood from which the box is made should not be warped or cracked.

CARE

Always wash your ink stone with clean water after use at the end of the day. As the traditional scholar says, "I can go three days without washing my face, but I cannot leave my ink stone unwashed for a single day."

It is usually best to use fresh ink, but old ink may be kept and used for creating special effects.

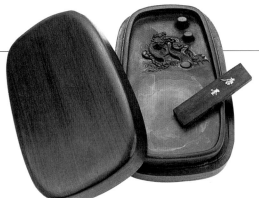

"Duan" ink stone with oil soot ink stick

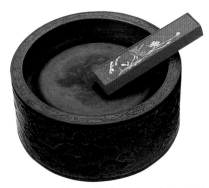

"Cheng Ni" ink grinder with cinnabai ink stick

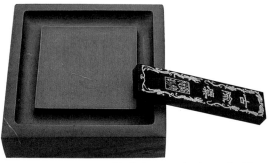

"Tao" ink stone with oil soot ink stick

"She" ink stones

preparing
materials

Calligraphy is a process that should not be hurried, but enjoyed at every stage.

If you are right-handed, set the brush and water pot at the top right-hand corner of the table. (If you prefer to use your left hand, place the above objects to your left, and reverse the following instructions.) Your water, ink stone, and ink stick should all be placed within easy reach on the right-hand side. The center area at the top of the table should be kept clear, so that paper can be moved up and allowed to hang down over the edge. Place the sample of calligraphy to be copied on the front left of the table.

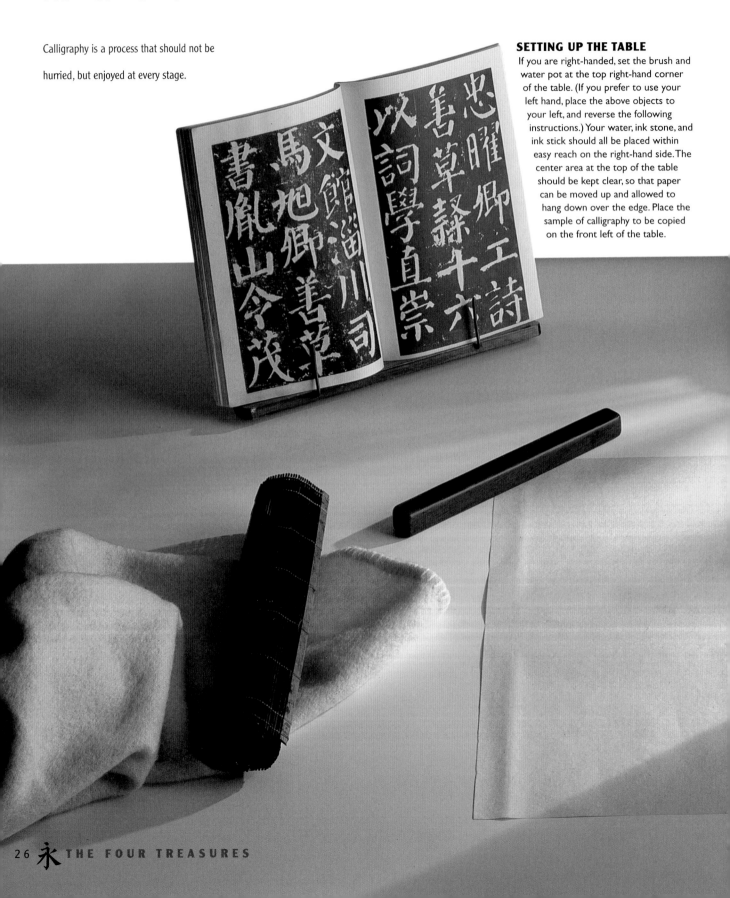

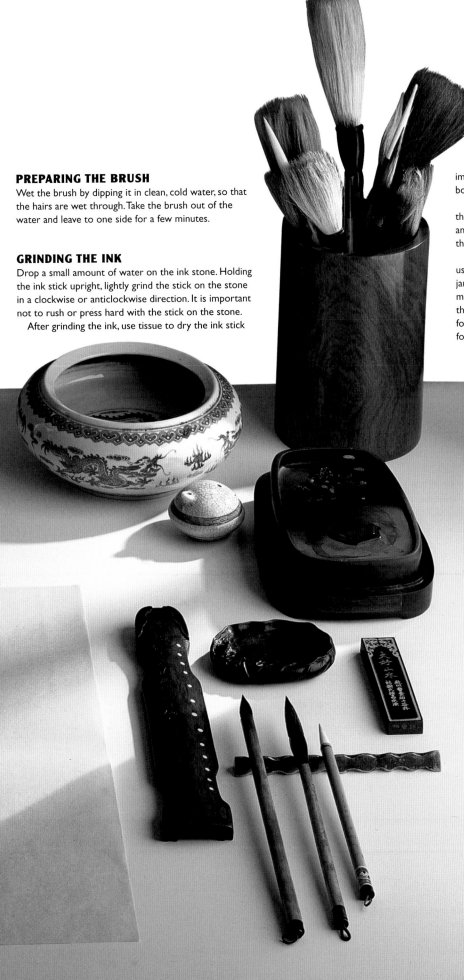

PREPARING THE BRUSH

Wet the brush by dipping it in clean, cold water, so that the hairs are wet through. Take the brush out of the water and leave to one side for a few minutes.

GRINDING THE INK

Drop a small amount of water on the ink stone. Holding the ink stick upright, lightly grind the stick on the stone in a clockwise or anticlockwise direction. It is important not to rush or press hard with the stick on the stone.

After grinding the ink, use tissue to dry the ink stick immediately. If left damp, cracks can develop on the bottom of the stick.

As you grind, this is the time to contemplate the page of calligraphy that you are going to copy, and settle your mind and heart ready for doing the calligraphy.

While it is possible to practice calligraphy by using ready-made bottled ink with a dish and jam jar of water, it is recommended that the traditional method be followed from the beginning. Grinding the ink prepares the mind, and must also be good for the health as calligraphers have a reputation for longevity!

holding the brush

The brush must be held in a way that gives the artist control, but feels comfortable and natural. As you work through the following steps, check the position and feel of your shoulders at every stage. It is common to tense the shoulders when beginning calligraphy, but this inhibits the natural flow of the body. The wrist should be flexible and the brush held vertical.

Before you start work, find a comfortable position in which to sit or stand (see page 29). The Four Treasures were in use in China centuries before the invention of tables and chairs, so, as you learn to hold the brush, rely only on the movements of your hand and arm to find "The Way of the Brush" – the position in which you can rotate the brush full circle with ease.

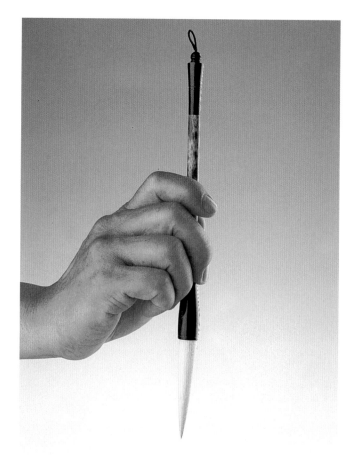

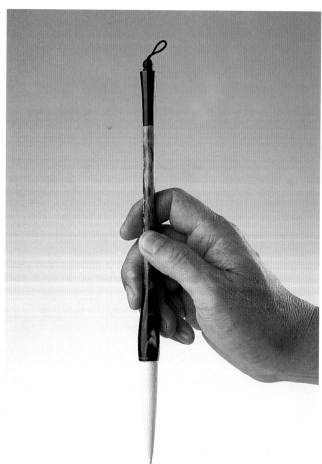

The correct hold

Use the thumb, forefinger, and index finger to hold the brush, supporting the other side of the brush with the ring finger and little finger. Keep the brush vertical, and the wrist loose. Above is the front view of the ideal hand and finger position on the brush. Shown left is the rear view of the same position.

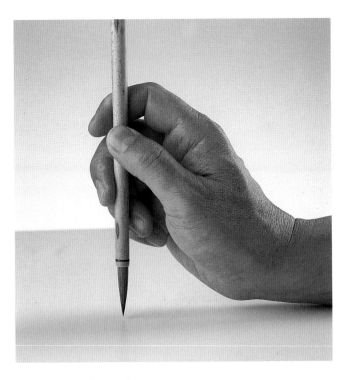

For small-scale work
When practicing small-scale calligraphy, you can rest your wrist lightly on the table. Make sure that your wrist and hand feel comfortable and are free to move.

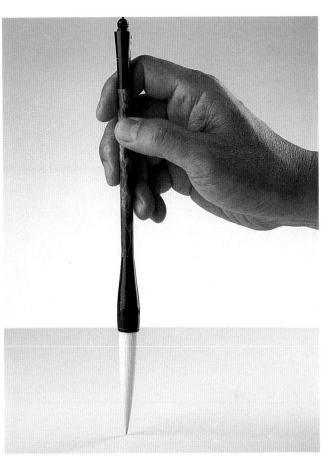

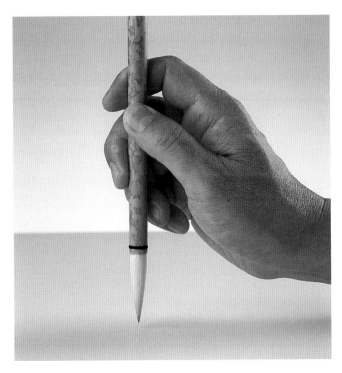

For medium-sized work
For medium-sized calligraphy – creating characters of around 1 in (2.5 cm) – elevate your wrist and leave the elbow resting lightly on the table so it can move freely.

For large-scale work
For large-scale calligraphy, the whole arm should leave the table. You will also need to alter your hold on the brush handle and move your fingers further up the handle shaft, away from the tip and the paper. This allows you to work on a greater scale.

It is important to hold the brush firmly while keeping the wrist, elbow and shoulder flexible. The effect must be a fine balance of precision and free flow. Good calligraphy often has the appearance of spontaneity, but this is achieved with practice and good posture as well as good intent.

HOW TO SIT AND STAND
Sit upright with your spine straight and shoulders relaxed, and keep your feet firmly on the floor. Check that the distance between your eyes and the paper is at least 1 ft (30 cm).

For large-scale calligraphy, it is best to adopt a standing position. Stand with your feet apart and the right foot slightly in front of the left. Keep your left hand on the table, leaning forward a little, and hold the brush in your right hand. Your wrist and elbow should be suspended, with the brush held straight.

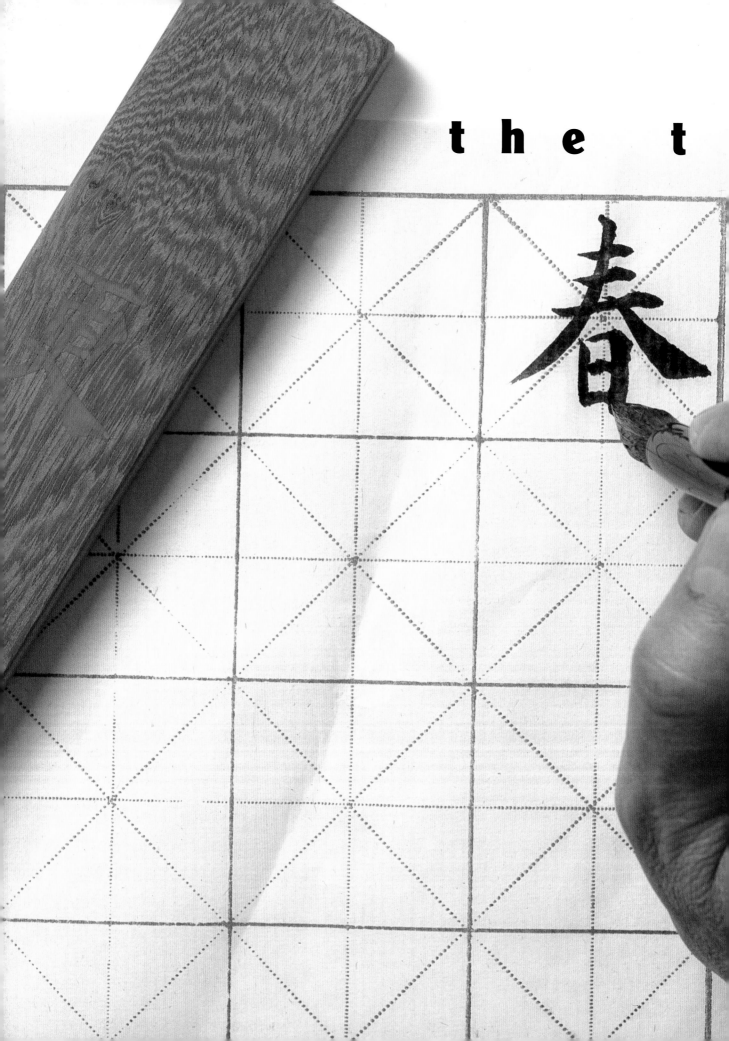

the t

chniques

This section of the book reveals the essential skills you need to create the cornerstone of Chinese calligraphy, the individual character. Elegant and simple Standard-style script is used to explain how the character is composed of up to eight strokes; each stroke and its variations are illustrated with practice exercises. Diagrams and examples show you not only how to perfect the different versions of each stroke, but how to plot the strokes and place the character harmoniously within its space.

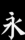

the eight strokes

There are thousands of Chinese characters, made of many different strokes. Wang Xi Zhi (CE 321-379), one of the greatest calligraphers in Chinese history, reduced all these strokes into eight basic components, contained within one Chinese character. This character, called Yong (meaning "forever") is also known, unsurprisingly, as The Eight Components of the Character Yong.

The Yong character does not include every stroke used to form all Chinese characters, but mastering its key eight strokes will allow you to form characters in any calligraphic style, from simple to more complex. Calligraphy students in China often spend months perfecting a single stroke, but with practice, even beginners can produce very impressive results. Mastery of calligraphic strokes provides an essential grounding for all forms of Chinese painting as well as all elements of calligraphy.

Although there are eight strokes in the character Yong, it is usually executed in five strokes: strokes 2, 3, and 4 form one continuous stroke, while 5 and 6 form another combined stroke. Both of these can be found in the final section on the individual stroke, the bend, or Zhe (see page 52).

As pages 34–51 show, each of the strokes has eight variations, making 64 strokes in all. The way each stroke varies depends on its placement within the character: examples illustrate the different styles of stroke. While some strokes have straightforward names, others such as "snap nail" and "rhino horn" (see page 49) hint at the energetic qualities the stroke requires. These strokes range from small, but vigorous, dots to complex bends and hooks, which may change direction several times before the brush leaves the paper.

Even the smallest strokes are executed with subtle twists of the brush and differences in pressure to create the required curves and angles.

Once you are more confident, you may find it useful to form the Yong character as a warm-up exercise before beginning your calligraphy.

Achieving the correct balance is essential when creating Chinese calligraphy characters. Beginners may find it helpful to draw the characters over a basic grid, such as the two shown below. Use the lines to draw your strokes at the correct angles, and keep the character perfectly centered, both horizontally and vertically.

As you practice the strokes and characters on the following pages, the "order of stroke" guides shown on page 54–57 will be very useful when you first create a particular character. You can then adapt these structural guides to other characters.

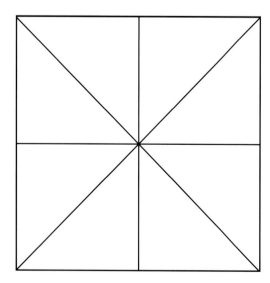

Star-shaped stroke placement guide

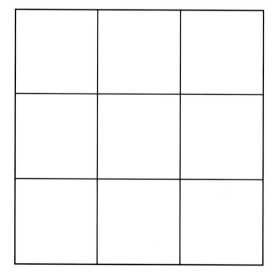

Nine Palace stroke placement guide

THE COMPONENTS OF THE CHARACTER YONG

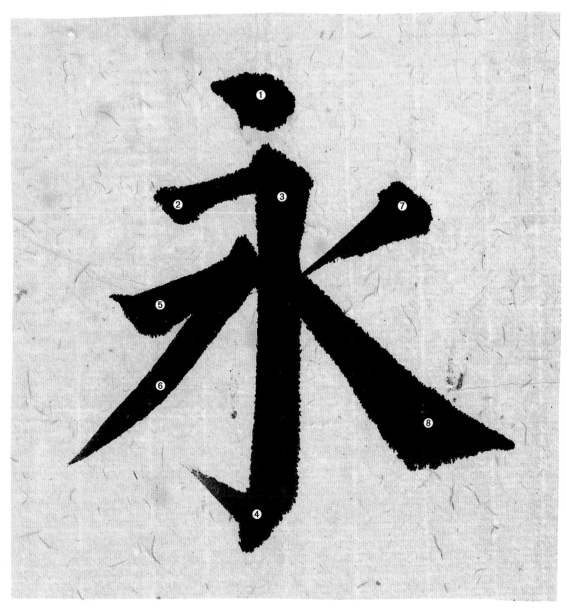

The categories of strokes represented by the character are:

1 The dot: *Ce* or *Dian*

2 The horizontal: *Lei* or *Heng*

3 The vertical: *Nu* or *Shu*

4 The hook: *Ti* or *Gou*

5 The raise: *Ce* or *Tiao*

6 The aside: *Lue* or *Pie*

7 The raise: *Ce* or *Tiao*

8 The right falling: *Zhe* or *Na*

principal styles

There are many forms, or styles, of Standard-style calligraphy script. For over 1,000 years, particular forms have been acknowledged as the best to study: Ou form, Yan form, and Liu form. A sample of each is shown here. Further examples are found in copy-books of stone rubbings from specialist Chinese art stores.

Briefly try all three styles, then choose the one with which you feel most comfortable. Once you have settled on a style, practice it well before attempting any others. Calligraphers all have favorite styles and, in time, you will develop your own.

Use the eight basic strokes in "Yong" (see page 33) to create the characters.

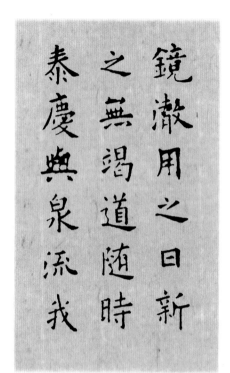

1 Ou form
(created by Ou Yang
Xun, CE 557–641)

dragon

1 Ou Yang Xun, from Hun Nan Lin Xiang in South China, working in the decades of the 7th century, before the golden age of calligraphy, was renowned for his diligence in the study of the art. He was known to have pored over a book, *Zhi Gui Tu*, the work of the great Jin dynasty calligrapher Wang Xi Zhi, a monumental text written in order to teach Wang's son calligraphy. This was Ou's greatest treasure, and he is reputed to have deprived himself of sleep in order to study it. He also devoted the same zeal to the Suo Jing text carved on stone monuments. Ou visited the stones, remaining there for several days and nights at a time in order to accomplish his studies. Another influence was the northern-style calligrapher Liu Chow, a post-Han dynasty teacher.

Ou's style is a combination of all the above, made distinct by his forceful, but elegant use of the brush to form angular, well-ordered strokes. The resulting structure of the characters is both balanced and vibrant.

The best example of his work is an essay on the Jiu Cheng Gong, found in the Jiu Cheng Palace in China.

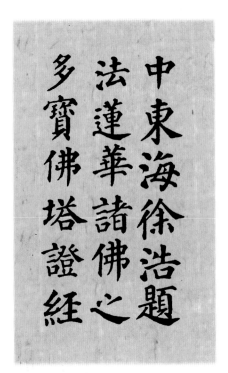

2 Yan form
(created by Yan Zhen Qing, CE 709–785)

calligraphy

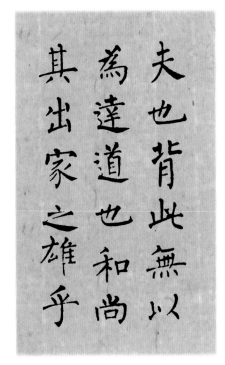

3 Liu form
(created by Liu Gong Quan, CE 778–865)

bone

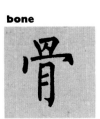

2 **Yan Zhen Qing**, product of the golden age of the Tang dynasty, was born in China's Shan Dong Lin Yi. Yan is well known for his articles on literature in the Standard-style script and Running Script. In conversation with Zhang Xu, another famous Tang dynasty calligrapher of the time, both agreed that the use of the brush in calligraphy should demonstrate the qualities of a bending golden hairpin – strength and resilience. His strokes are plump and powerful, and the authoritative structure of his characters displays stability and solidity.

Yan's essay about the Duo Bao Ta Pagoda stands as one of the best examples of his work; the original remains in China.

3 **Liu Gong Quan,** from Shan Xi Huyan, had a very unambiguous approach to life. In reply to the emperor's enquiry as to the best way to use the brush, he replied that "An upright heart makes for an upright brush", pointing out that your brushwork always reflects your personality – and implying that it is possible to improve both!

Liu combined Ou's refined style of elegant, angular strokes with the fullness and weight of Yan's characters to create his own disciplined style, which demonstrates clarity and structure.

Liu's most celebrated work is an essay, again about a pagoda: the Buddhist Pagoda of Xuan Mi (Xuan Mi Ta).

1 : t h e d o t

In Chinese calligraphy, the dot is known as *Ce* or *Dian*. It is created by moving

the brush in a clockwise circle, making a soft, triangular form. Begin by using

just the tip of the brush (1), then use the body of the brush (2) in a stroke to

the right (3), pressing downward (4). Complete the dot, again using just the tip

of the brush (5). Working from the examples on pages 38–39, practice the dot.

THE MOVEMENT OF THE BRUSH

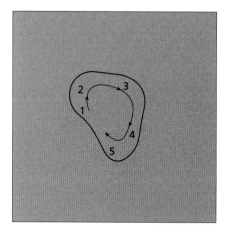

Dot Technique

1 **"Hiding the tip":** rest the brush
tip as above.

2 **"Tip turning up":** turn the tip
upward and to the right.

3 **Press the brush to the right.**

4 **Press the brush downward.**

5 **Return the brush tip to
complete the dot.**

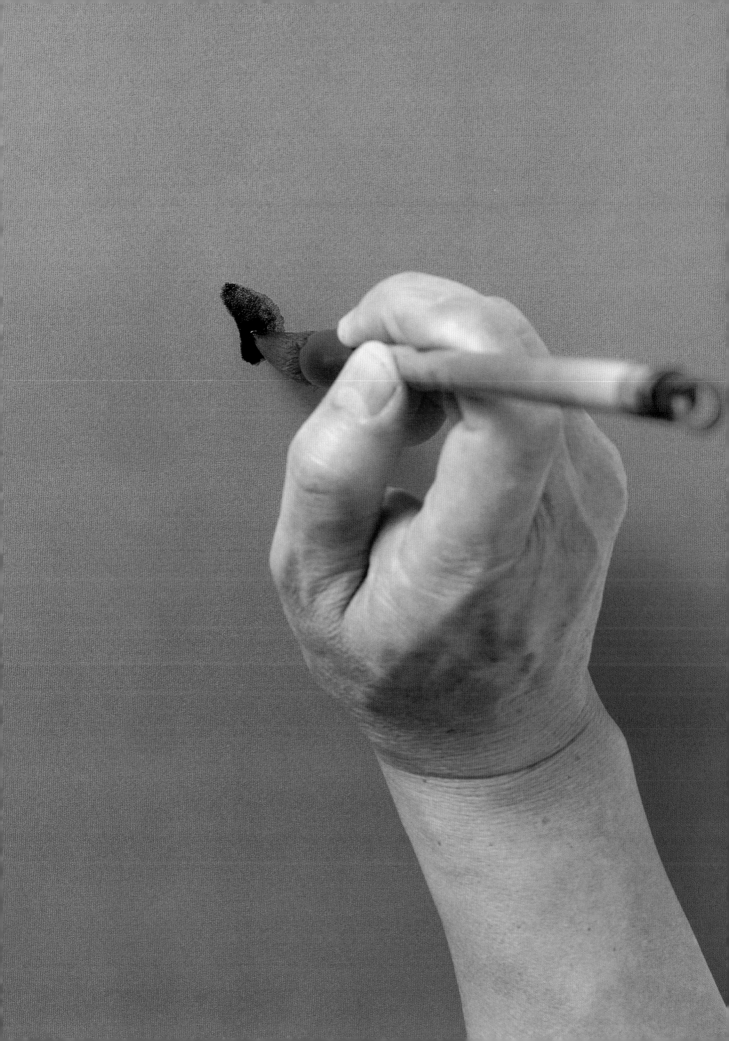

dot styles

1 Top dot (Apricot stone)

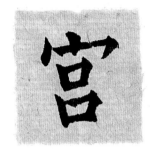

Palace

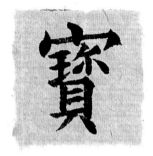

Treasure

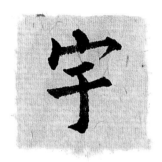

Universe

2 Bottom dot

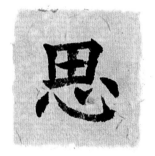

Think

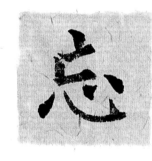

Forget

Table

3 Left dot

Heat

Must

Nature

4 Right dot (Flat dot)

Ask

Not

Today

 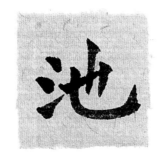

5 **Top-left dot** *Pool* *Sink* *Pure*

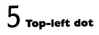 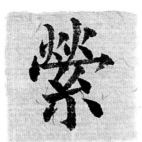 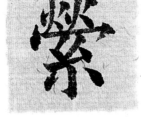

6 **Top right dot** *Sparkle* *Me, I* *Coordinate*

 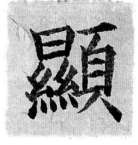

7 **Bottom left dot** *Nothing* *Happy* *Appear*

 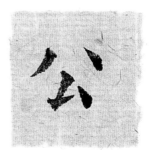 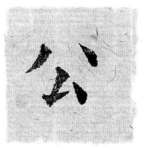

8 **Bottom right dot** *Deep* *Male* *Ditch*
(Mouse dropping)

2: the horizontal

To create the horizontal stroke, known as *Lei* or *Heng*, touch the brush to the paper, allowing a slight drop as the brush makes contact (1). Press briefly, not moving the brush from the paper, then turn the tip to the right (2). As you reach the end of the stroke (3) lift the tip upward, then press the brush down to the right (4) rotate it, and pull it back up the stroke (5). Practice the variations opposite.

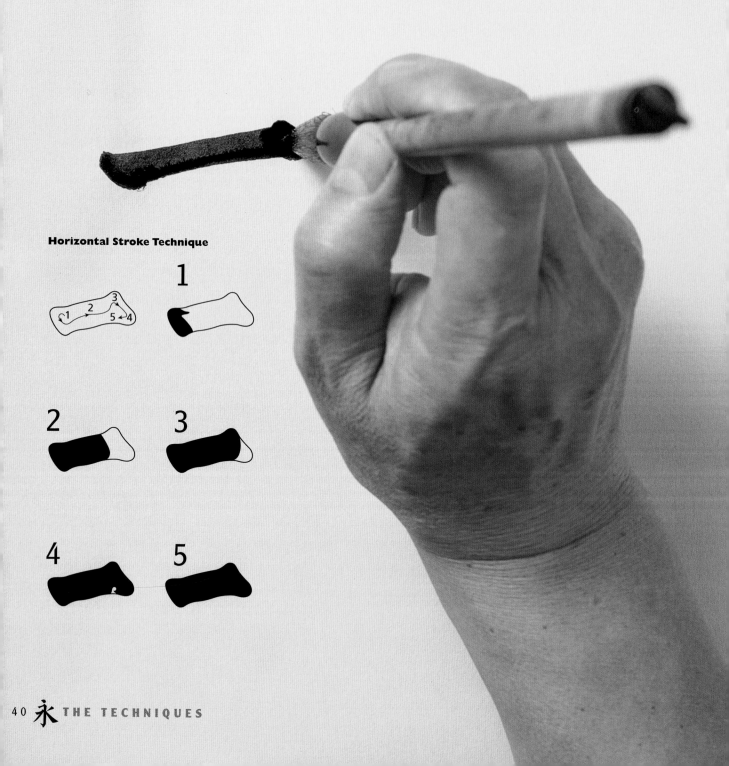

Horizontal Stroke Technique

1

2

3

4

5

HORIZONTAL STYLES

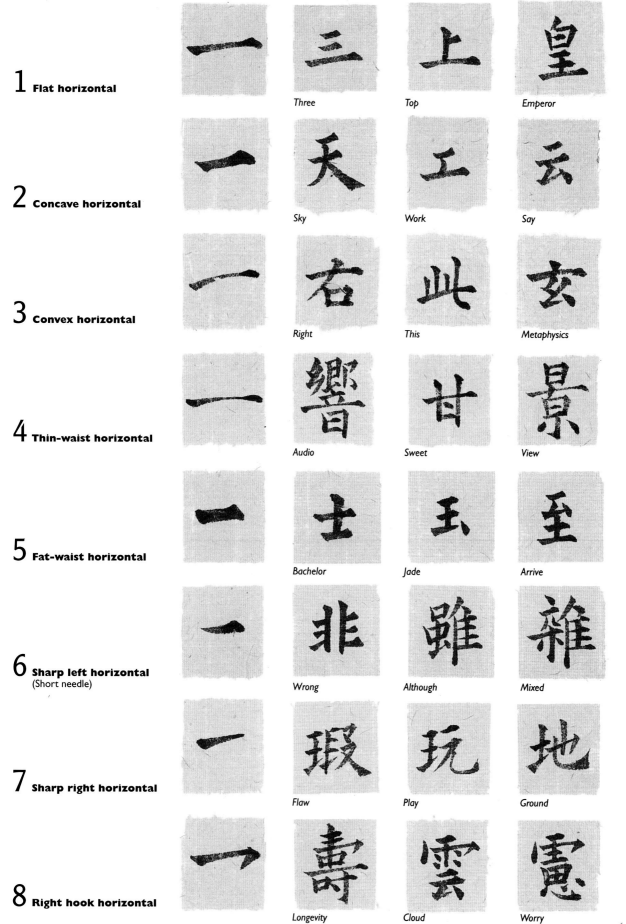

1 **Flat horizontal**

Three　Top　Emperor

2 **Concave horizontal**

Sky　Work　Say

3 **Convex horizontal**

Right　This　Metaphysics

4 **Thin-waist horizontal**

Audio　Sweet　View

5 **Fat-waist horizontal**

Bachelor　Jade　Arrive

6 **Sharp left horizontal**
(Short needle)

Wrong　Although　Mixed

7 **Sharp right horizontal**

Flaw　Play　Ground

8 **Right hook horizontal**

Longevity　Cloud　Worry

3: the vertical

The vertical is called *Nu* or *Shu*. Working down the paper, touch the brush onto the paper (1). Pause for a moment, then turn the tip and press down (2). Rotate the tip and pull downward (3). At the end of the stroke, pause again (4), then pull the bristle tips a little way back up the stroke, retracing the line for a neat finish (5). Practice the variations opposite.

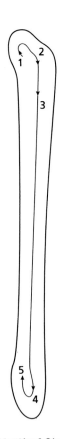

**Vertical Stroke
Technique**

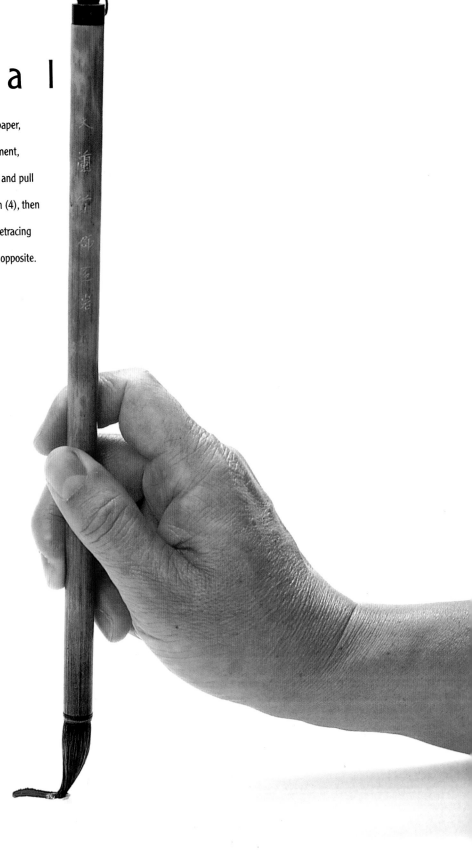

VERTICAL STYLES

1 **Straight vertical**

Cherish Bosom Spirit

2 **Left curve vertical**
(Dew drop)

Moist Unoccupied Hear

3 **Right curve vertical**
(Back vertical)

Not River island Series

4 **Thin-waist vertical**

General Refuse Wash

5 **Fat-waist vertical**
(Iron column)

Holy Stone First month of a season

6 **Sharp-top vertical**

Auspicious Good fortune Rite

7 **Sharp-bottom vertical**
(Hanging needle)

South Emperor Offer

8 **Bent-feet vertical**

This Overspread Deep

4: the hook

For the hook, *Ti* or *Gou*, lower the brush onto the paper. Move it downward briefly as a vertical stroke (see page 42, steps 1–3), then lift the tip (4), and press down (5). Tip the brush upward and turn right (6). Lift the brush cleanly off the paper to leave the neat hook shape (7). Practice the variations opposite.

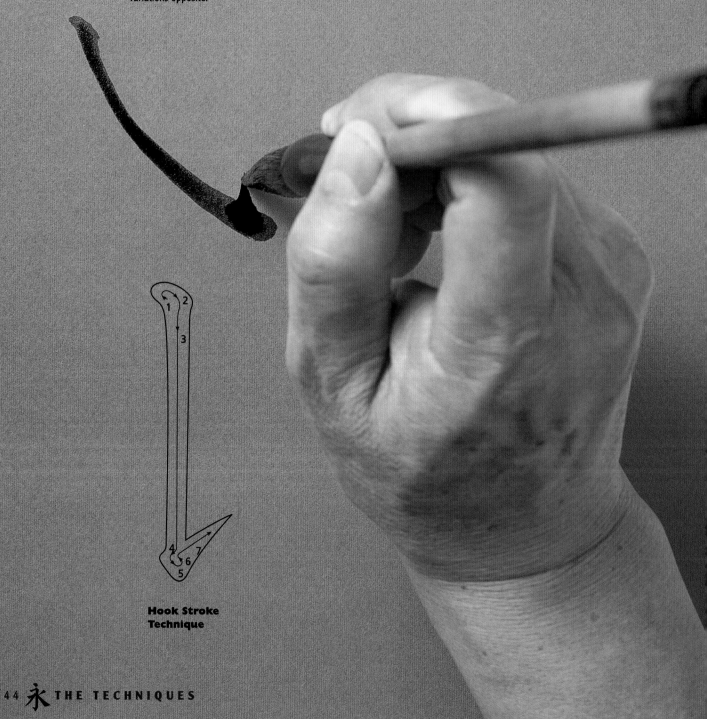

Hook Stroke Technique

HOOK STYLES

1 **Straight hook**

Deer Also Eat

2 **Curve hook**
(Jade hook)

Purple Feeling Carry

3 **High hook**
(Floating goose)

Pure Chaos Dragon

4 **Short hook**
(Horizontal dagger)

Heart Forget Must

5 **Slant hook**

I, Me Succeed Martial

6 **Two-curve hook**

Surname Ability Discipline

7 **Three-curve hook**

Light Watch Especially

8 **Four-curve hook**

Nine Wind Air

5 and 7: the raise

To create *Ce* or *Tiao*, the raise, touch the brush to the paper (1), then press the brush downward (2). Turn the tip and press to the right (3), then move it with confidence at an angle of 45° from left to right up the page (4). As you tail off, lift the brush off gradually to give the stroke a sharp tip. Practice the variations opposite.

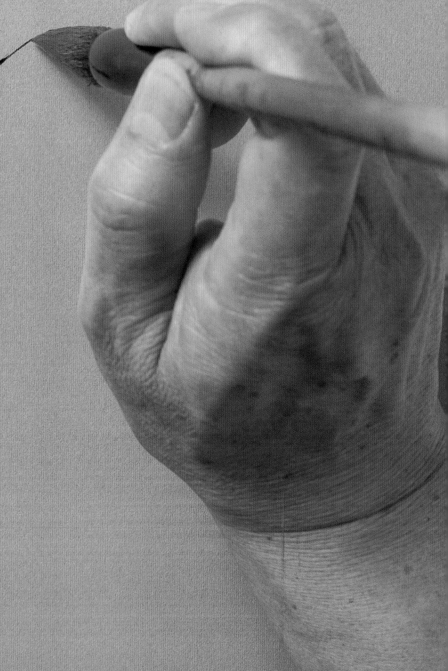

Raise Stroke Technique

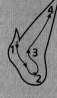

1

2

3

4

RAISE STYLES

1 **Upward raise**

漢 Man 波 Wave 流 Flow

2 **Downward raise**

蒸 Steam 茅 Thatch 舊 Old

3 **Leftward raise**

質 Quality 重 Heavy 水 Water

4 **Rightward raise**
(Tiger tooth)

如 As 地 Land 紀 Discipline

5 **Up leftward raise**

子 Son 乎 Question 永 Forever

6 **Up rightward raise**

扶 Support 握 Hold 揚 Raise

7 **Bottom leftward raise**

立 Stand 並 Combine 其 His, Her

8 **Bottom rightward raise**

昔 The past 茨 Vine 蓱 Duckweed

6: the aside

The aside translates as *Lue* or *Pie*. Press down lightly (1), then turn the brush tip and press to the right (2). Work with confidence, as you did for the Raise (see page 46). Now move down (3) and decrease the pressure on the brush – this produces a short, claw-like downstroke (4). Practice the variations opposite.

Aside Stroke Technique

ASIDE STYLES

1 **Straight aside**
(Rhino horn)

Human

At

Person

2 **Curve aside**
(Sickle)

Big

History

Peaceful

3 **Thin-waist aside**
(Hanging dagger)

Room

Corridor

Do Not

4 **Fat-waist aside**
(New moon)

Offer

Deer

Celebration

5 **Curved-head aside**

But

Wasteful

Rest

6 **Curved-tail aside**

Wind

Muscle

A minister

7 **Long-curve aside**

Dusk

Examine

Ascend

8 **Short-curve aside**
(Snap nail)

Water

Drink

Finish

8: the right falling

Zhe or *Na*, literally "right-falling", begins at the top left (1). Starting with very light pressure, press down and gradually increase the pressure on the paper to thicken the stroke, then move diagonally down to the bottom right (2 and 3). Pause and press at the base of the stroke (4), then, keeping the brush on the paper, move away and slightly upward to the right to complete the stroke. Practice the variations opposite.

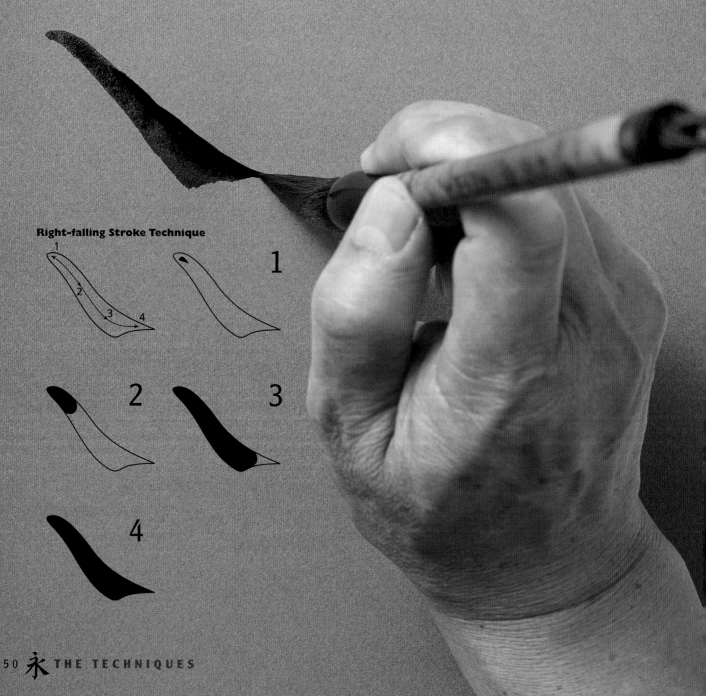

Right-falling Stroke Technique

1

2

3

4

RIGHT-FALLING STYLES

1 **Straight right falling**
(Golden sword)

Highest

Original

Join

2 **Curve right falling**
(Slice)

Gold

Summer

Order

3 **Sharp-head right falling**

Beautiful

Change

Sort

4 **Square-head right falling**

Lack

Over

Of (posessive)

5 **Long right falling**

The way (Dao)

Far

Avoid

6 **Short right falling**

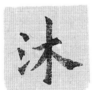

Bath

After

Extreme

7 **Straight-oppose right falling**

Europe

Drink

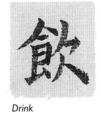

Food

8 **Snap-oppose right falling**

Alike

Peace

Collect

technique:
the bend

Stroke 2, the horizontal (see pages 40–41), provides the basis of the bend, or *Zhe*. It should

be executed as one continuous stroke, beginning by performing a horizontal (1–4), then

pressing downward (5), and pulling down (6). As you reach the end of the stroke, press down

and stop (7), then turn the tip up (8). Lightly lift the brush off the page to give a claw-like

finish (9). Practice the variations opposite.

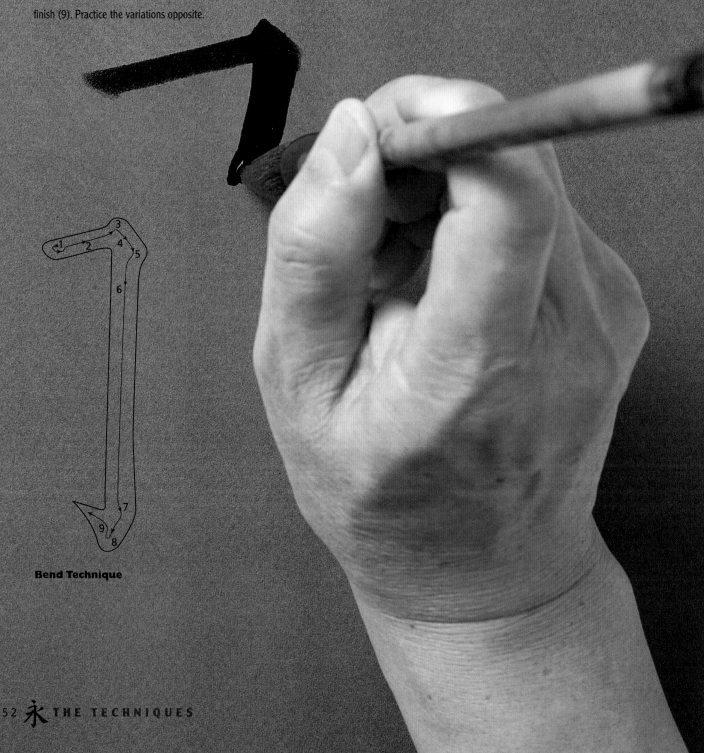

Bend Technique

BEND STYLES

1 Straight bend
(Central hook)

	東	事	機
	East	*Matter*	*Machine*

2 Curve bend

	子	乎	學
	Son	*Question mark*	*Study*

3 High bend
(Bending ruler)

	月	國	有
	Moon	*State*	*Have*

4 Short bend

	而	高	尚
	But	*High*	*Noble*

5 Slant bend

	功	力	動
	Merit	*Power*	*Move*

6 Two-curve bend

	也	為	池
	Also	*For*	*Pool*

7 Three-curve bend

	及	建	延
	And	*Construct*	*Extension*

8 Four-curve bend

	隨	降	階
	Follow	*Down*	*Stairs*

creating characters

You should follow the correct sequence of strokes when creating Chinese characters. Practice building each character on pages 55–57 in the order shown; the key rule is to work from the top downward and from left to right. As you work, consider the placement of each character in its own space, and its proportions within the whole of your work.

Here, the characters for three groups of concepts: the phrase "the Art of Chinese Calligraphy", Spring, Summer, Fall, and Winter, and North, South, West and East, are shown alongside a stroke-by-stroke breakdown, explaining the correct order for creating the characters. To achieve elegant composition and to position the strokes correctly, use the breakdowns below. You can also refer to or photocopy the stroke placement guides (see page 32) to use as practice guides. Then create each character in the order of the strokes shown, so you can become familiar with the sequence in which a character is built.

The Art

of

Chinese

Calligraphy

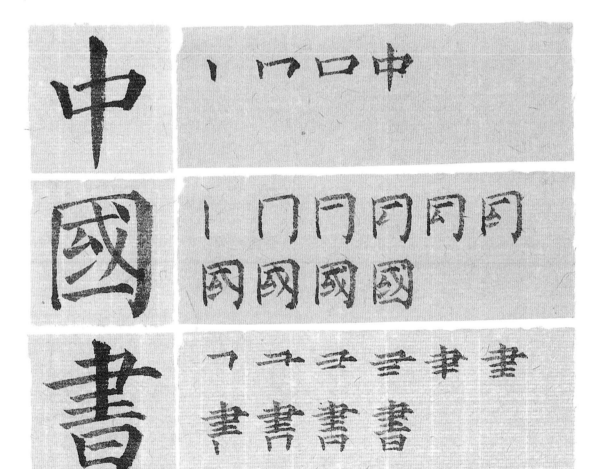

All these characters are square-shaped or placed in the shape of a square. As you practice each of the characters on the following pages, keep in mind the proportions of your character both in itself and on the page.

Spring

春

一 一 三 夫 夫 春
春 春 春

Summer

夏

一 一 厂 厅 厅 百
百 頁 頁 夏

Fall

秋

丿 一 千 千 禾 禾
禾 秋 秋

Winter

冬

丿 夕 久 冬 冬

Using the square shape will teach you to bear in mind the composition of the characters, enabling you to apply the same techniques of sequence and harmonious placement for all the other characters that you will recreate in the following chapters.

North

South

East

West

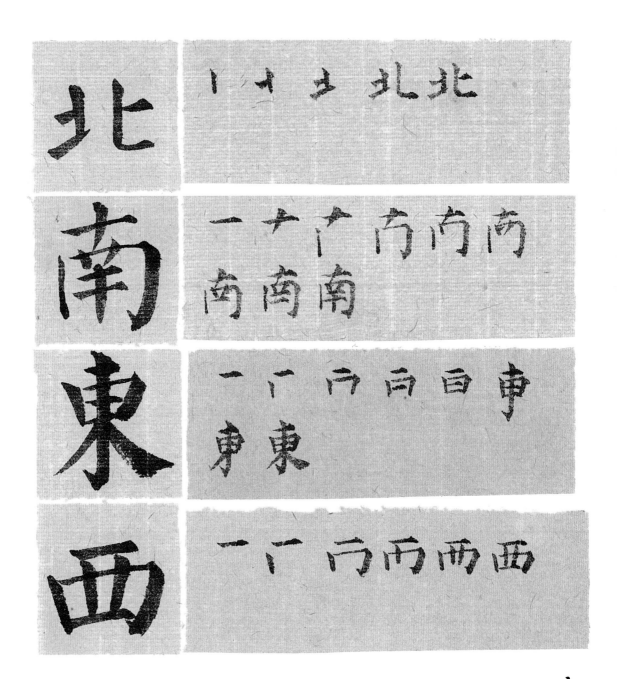

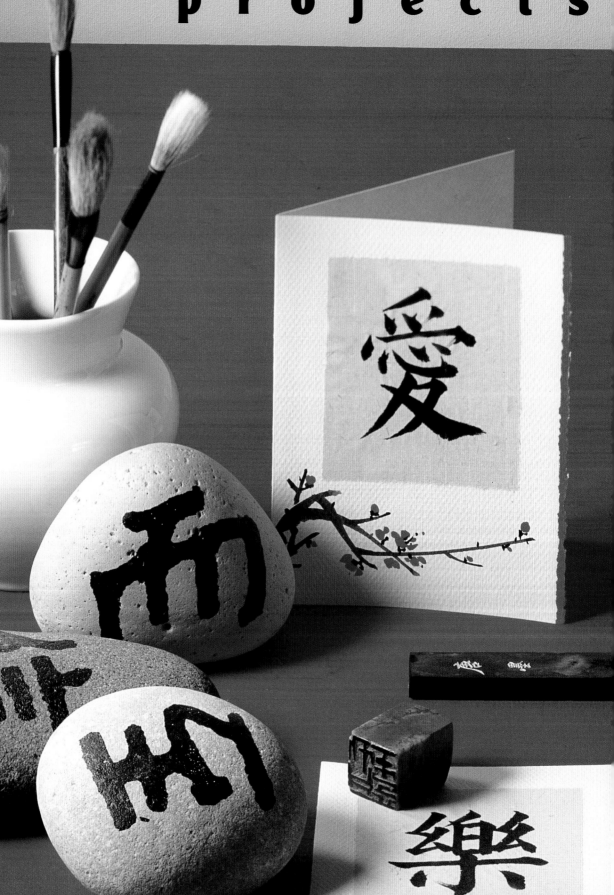

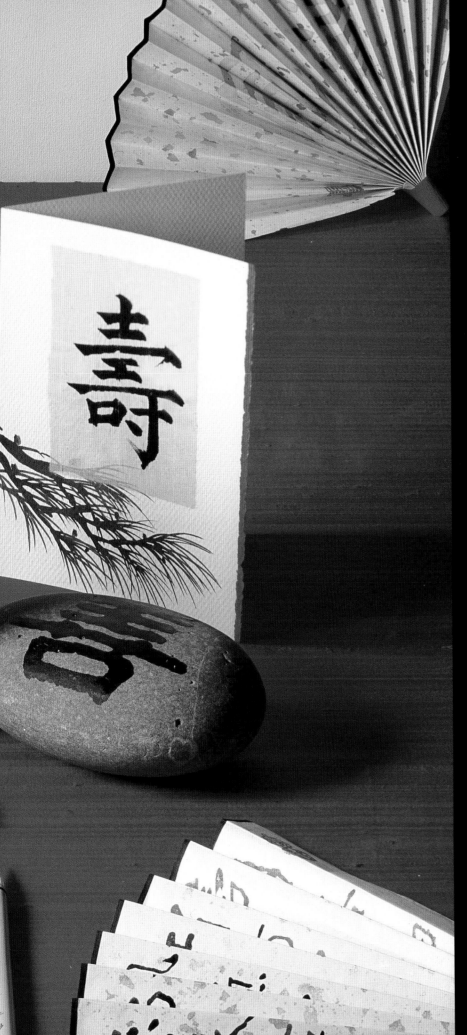

Use your calligraphy skills to create beautiful objects for your home and loved ones. Using simple characters, learn how to work in this ancient art to decorate fans, greetings cards, hangings, small sculptures, papercuttings, and even a tee-shirt. You can also create a personal seal and learn how to mount finished work. The Inspirations chapter (see page 112), provides authentic traditional designs, names, motifs, and poetry to use as variations on any project.

the fans

For many people, fans are synonymous with ancient Chinese art. In many ways, these are the ultimate display pieces for calligraphy, the many shapes and materials of fans available today having evolved through thousands of years.

The five elegant fans shown on the following pages provide a delightful backdrop to your calligraphy and can be used, or laid flat as a display, or mounted traditionally as decorative artifacts on the wall. The artistic purpose of working with a fan is to create a harmonious relationship between the shape and placement of the characters and the shape of the fan. Creating perfect balance within a composition is a key tenet of calligraphy practice.

When creating a fan, you can either purchase ready-made, folded fans, which are available from specialist stationers, or you can cut (see page 68), edge (see page 69), fleck (see page 65), and fold your own fan. If you are buying a ready-made fan, make sure before you begin that you gently extend the fan to flatten its folded surfaces and place it on a felt backing.

The folded fan projects use two simple characters; the first is the archetypal, ancient character meaning "spring", while the second folded fan project uses the folds of the fan to frame columns of characters and illustrate an arrangement of large and small calligraphy scripts from a section of spiritual Daoist poetry. The open book fan, so named because of its characteristic shape, makes best use of the drama of black and white; the simple character of Happiness stands out boldly against the paper, which is then flecked with gold. The round fan displays the character Love written in oriental lacquer-red to provide an ideal love token. An unfolded fan, for display purposes only, completes the group; created from a simple stencil, the plain shape contrasts with the dashing dragon character spread across the paper.

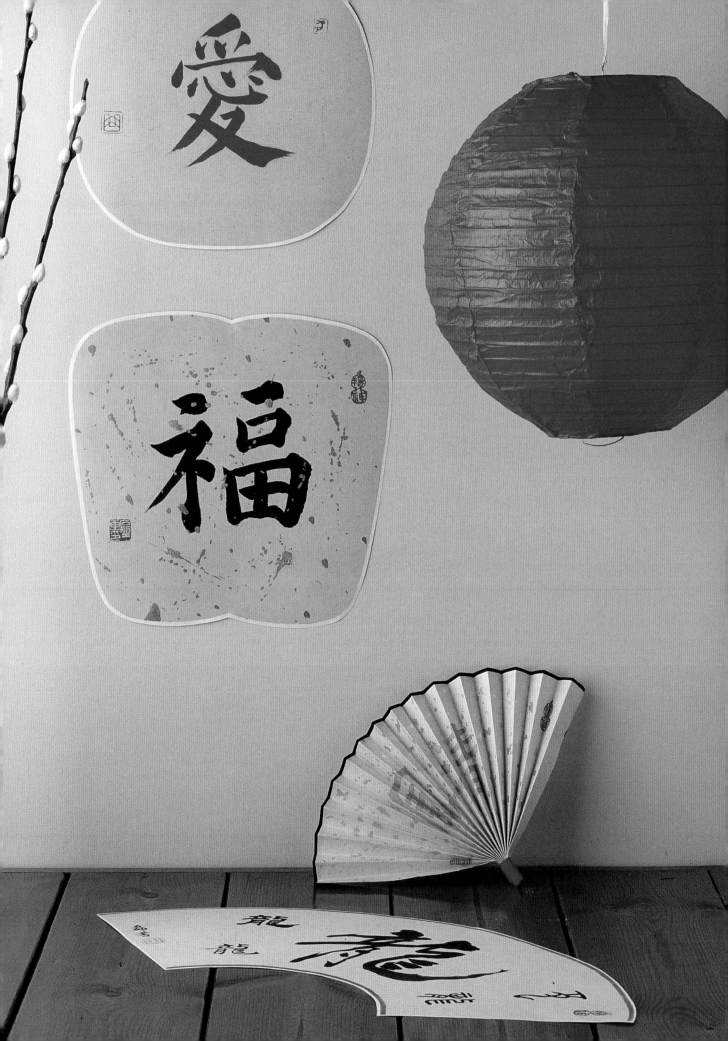

two folded fans

These two fans are ideal for those new to the fan-making arts: the first, using the Spring character, is simple to write and to colour; while copying the Dao poetry extract onto the fan folds (right) provides a valuable exercise in position and balance.

Simple Spring fan

1 Positioning the characters

Place your copy book as close to your work as is comfortable for you. Plot the position of the two characters on each side of the central point of the fan. If necessary, measure and mark the center of the fan using a pencil. Work the calligraphy using a large orchid bamboo brush, pressing the folds of the fan flat with your free hand. You can vary the effect by using colored inks rather than traditional black. Here, a fresh jade calligraphy paint was chosen to reflect the vibrancy of spring, or "Fresh Breeze", the English translation of the calligraphy.

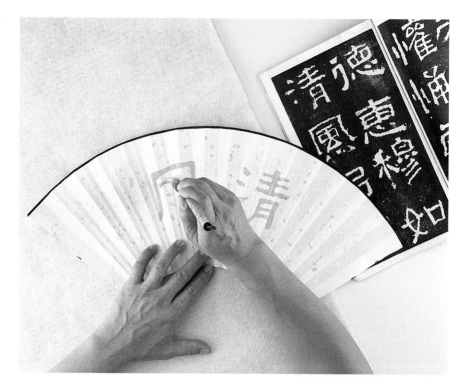

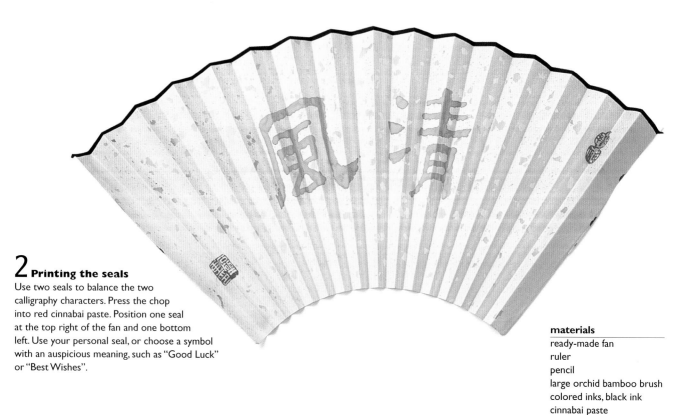

2 Printing the seals

Use two seals to balance the two calligraphy characters. Press the chop into red cinnabai paste. Position one seal at the top right of the fan and one bottom left. Use your personal seal, or choose a symbol with an auspicious meaning, such as "Good Luck" or "Best Wishes".

materials

ready-made fan
ruler
pencil
large orchid bamboo brush
colored inks, black ink
cinnabai paste
2 seals of your choice

Dao poetry fan

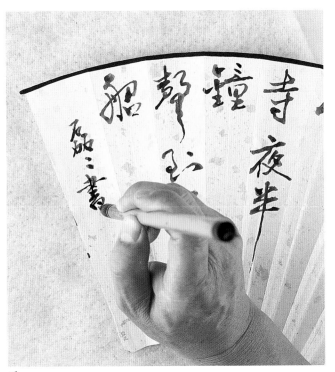

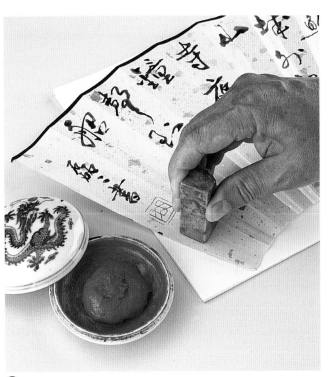

1 Positioning the characters

Plot the position of the characters, working downward in vertical columns from right to left across the fan. Note that a single character appears at the top of each fold, and columns of characters appear only on alternate folds. Use a large orchid bamboo brush for both the larger and smaller characters. Rest after each column to assess the balance of your work.

2 Balance with the seal

The chop seals and balances your work. Here, it is roughly the same size as the smaller calligraphy on the far left of the fan. Think of the chop as an integral part of the design, and leave room for it; it should never be merely an afterthought.

3 Display

Fans need not be functional. Many Chinese households display decorated fans as flat artwork, or you can set them on fan frames for a table display.

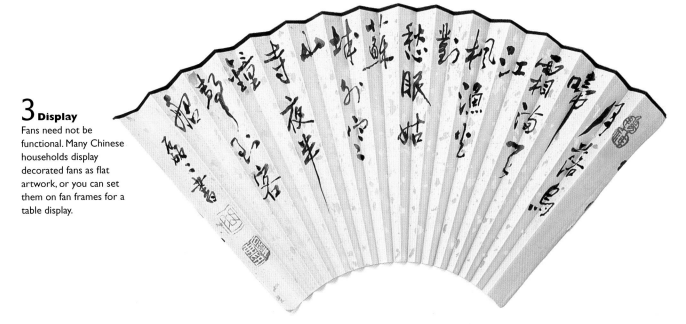

open book fan

Many fan shapes evolved from the round fan, including the oval, diamond, begonia, blossom, and this open book shape, among many others.

The Happiness character has been used for this example. In Chinese homes, a fan or talisman is sometimes hung upside down on the front door to signify that happiness is arriving to brighten your life and your home.

materials

black ink	gold calligraphy ink
brush	fan paper or
2 medium-sized	ready-made fan
brushes	seal

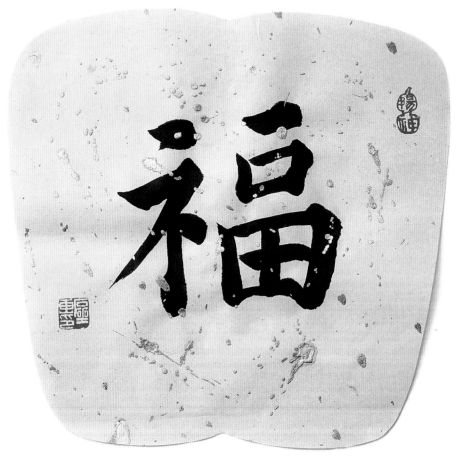

You can use a variety of characters (see pages 112–126) as the central emblem for your fan. It is traditional to match the sentiment expressed in the character to the recipient, and you could also create the character of their name (see the guide on page 114–120). If you are using the finished piece as a hanging in your home, you might consider using the ancient Chinese mottoes for Long life (see page 71) or Good Luck (see page 71).

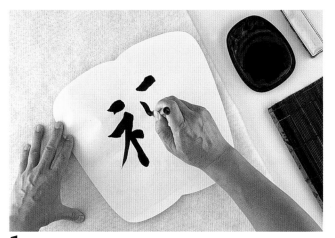

1 Depth of the stroke

Mix a deep black classical ink. Test the brush on a spare piece of similar paper to check that the lines produced are thick and solid. Working from the top of the fan downward, create the strokes.

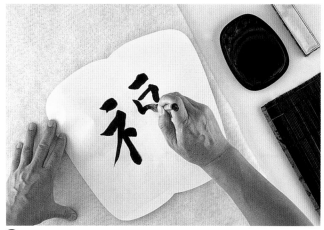

2 Working through the character

As you progress through each stroke, remember to keep your elbow above, and horizontal to, the paper. Keep working briskly – the flow of the character, or 'Qi' energy, is essential to its success.

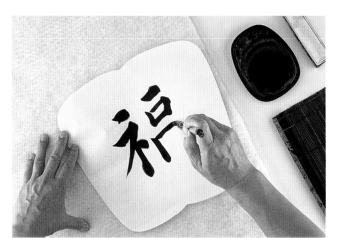

3 Downward strokes

To create strong, flowing downward strokes, use the brush in a stroking motion, applying the tip of the brush more firmly at the top, and then come back up the paper a few millimetres as you hit the base of the stroke.

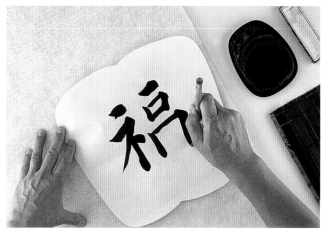

4 Completing the character

As you work on longer, larger strokes, try not to lift the brush away from the page between movements. Only reload the brush between strokes, if necessary, and always between sections of the character.

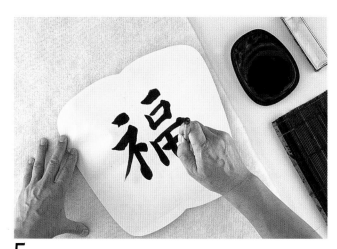

5 Assessing the character

As you move toward the finish, consider the balance between the black and white space on the paper. It should be harmonious; if you feel it looks too empty, feel free to add another character to lend the piece harmony.

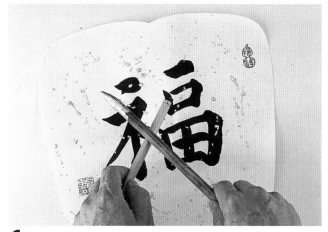

6 The golden finish

Gold calligraphy ink creates the speckled final effect. Load two medium-sized brushes with ink, cross them, tapping each against the other, as you move them round the paper in an anti-clockwise direction. Print your seal.

round fan

In this project, the Love character is used on the classic round fan shape, making the fan ideal as a gift for a partner or family members. Evidence of round fans goes back to very early times but the shape was first popularized fairly late in the history of calligraphy, during the Song dynasty (CE 960–1127) by Emperor Hui Zong (see page 14). Subsequently, the round fan has become a very important art form in both Chinese painting and calligraphy, and is used as a classic surround for many important pieces. Examples of calligraphy in this shape are shown below; it is often used as a frame for poems, prose, or mottoes. To vary your work in this way, choose a poem or proverb to copy from the inspiring selection on page 121.

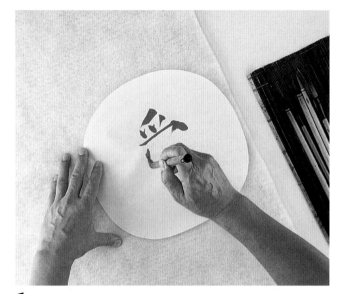

1 Begin the love character by first forming a short rising stroke and then three dots. These are followed by the "roof", starting with a dot and long right hook horizontal. Make the first of the strokes below, with the dot shape to echo the first stroke you have created.

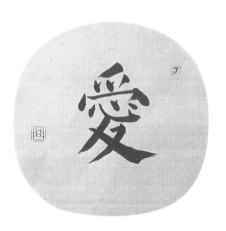

Left: Ideal as a gift, the simple elegance of the shape complements the character. The message on this fan is "Love", depicted in red ink or paint.

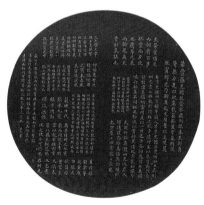

Left: This very popular combination uses gold paint on purple-sized silk. Written by an unknown scholar as a present to a friend, the personal seal cannot be deciphered, but the text is typically made up of sections of poems and prose.

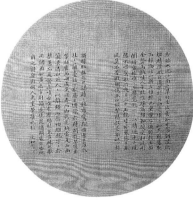

Right: This example of ink calligraphy on gold-sized silk was written by a lady scholar, Wen Ru, and is a prose poem describing the green bamboos south of the Yangtze River.

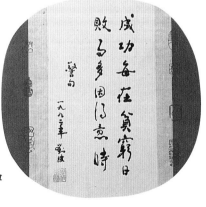

Right: A gift from Liu Bo, Qu Lei Lei's mother, that reads: "Tribulation often breeds success. Defeat often follows complacency. Remember!" The original message was written on grass paper, but has subsequently been mounted as a round fan.

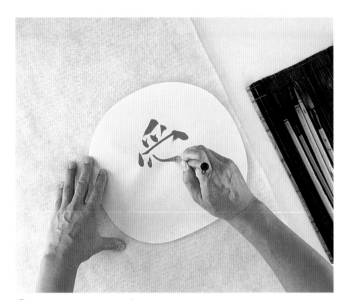

2 Now create the short bending hook, sweeping to the right and tailing quickly back up the stroke then off the page to leave a thick, hooked end to your stroke.

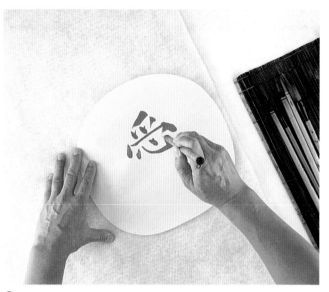

3 As you finish the hook, move on to draw the rest of the four strokes in the lower half of the character, always working from left to right. Next, insert two dots, which are to be the radical "heart" of the character.

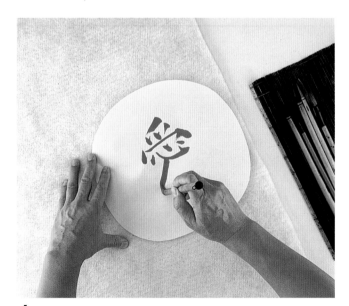

4 Move on to the base area of the character. Create a left aside stroke, tailing the brush off sharply as you finish to leave a pointed tip.

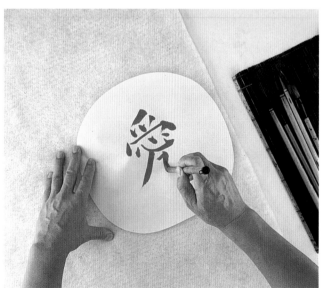

5 Add the second left aside, then complete the character with a right falling stroke. If you can, stamp two seals in balance with each other to complete the fan.

unfolded crescent fan

This elegant fan, without folds, is for display purposes; it offers a perfect contrast to the simplicity of its calligraphy. Using calligraphy paper, it is very easy to create an unfolded fan; simply cut a crescent from the center of a sheet, using a card template that you can keep for reuse. The fan shown here is decorated with the character Dragon. The dragon is the fifth animal of the Chinese zodiac, and is often represented in all forms of Chinese art. This fan would be an ideal gift for someone born in the year of the Dragon.

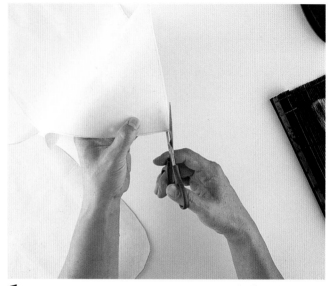

1 Making the fan leaf

On stiff paper or card, draw your fan shape and cut it out. Place this shape over your calligraphy paper and draw around the shape. Carefully following the outline, cut out the fan.

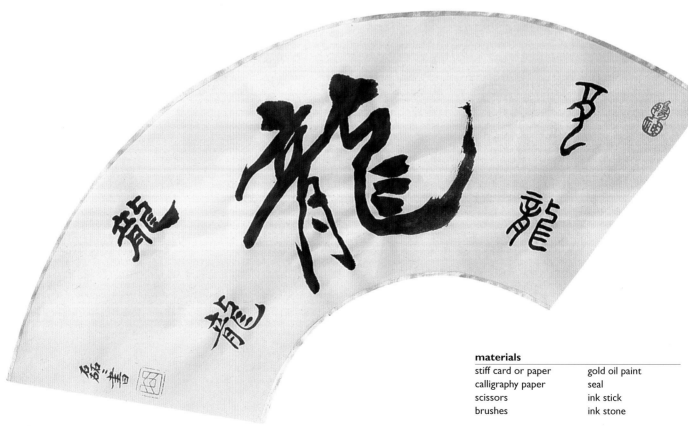

materials

stiff card or paper	gold oil paint
calligraphy paper	seal
scissors	ink stick
brushes	ink stone

2 Preparing the ink and brushes

First prepare your brush (see page 27). Soak it, then take it out of the water and leave it until you are ready to begin. Grind your ink, taking time to contemplate before you begin work on the calligraphy. As you progress in calligraphy, remind yourself that all the preparatory stages are important.

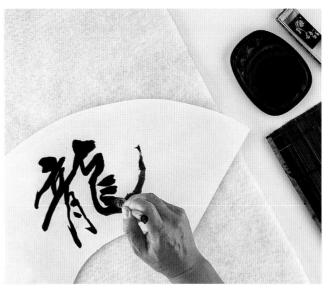

3 Writing on the fan leaf

Assess where you want to position your character. Here, the character Dragon, written in running script, has been placed in the center of the fan. You might like to practice the character on another sheet to work out the best size for the fan leaf.

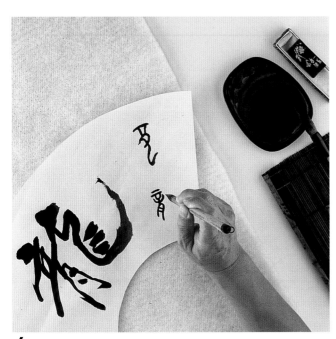

4 Additional characters

Other character styles, also depicting the word "dragon", can be used to frame the main character in the center. Position these so that they follow the angles of the fan rather than writing them in parallel to the main character. This also applies to your signature and seal.

5 Gold edging

Using a clean brush, add gold oil paint on the top and bottom of the fan leaf. This has the effect of lifting the design. Be sure to wash your brush thoroughly immediately after use. Once completely dry, the fan leaf is ready for mounting and framing.

greetings cards

With its origins buried several thousand years ago in the ancient history and myths of China, calligraphy is not just revered as the highest form of fine art, but as a mystical discipline. The simplicity of the characters, coupled with the spare yet delicate decoration, seeks to capture an epiphany of feeling, or "moment in time". When used to create cards of greeting for people you care about, the communication of feeling takes on a spiritual dimension. The cards become talisman-like, reverential objets d'art, pregnant with meaning and good fortune. Creating and working on a card for someone you care about is an act of love. Not only will the card thrill and delight the recipient, the good wishes will last as long as the card itself, which can become a keepsake, and even displayed as a work of art. The four cards here represent the most popular traditional greetings in the East, and each should be treated with reverence and dignity. Despite their ancient origins, the feelings they express are still as poignant and powerful today in the 21st century.

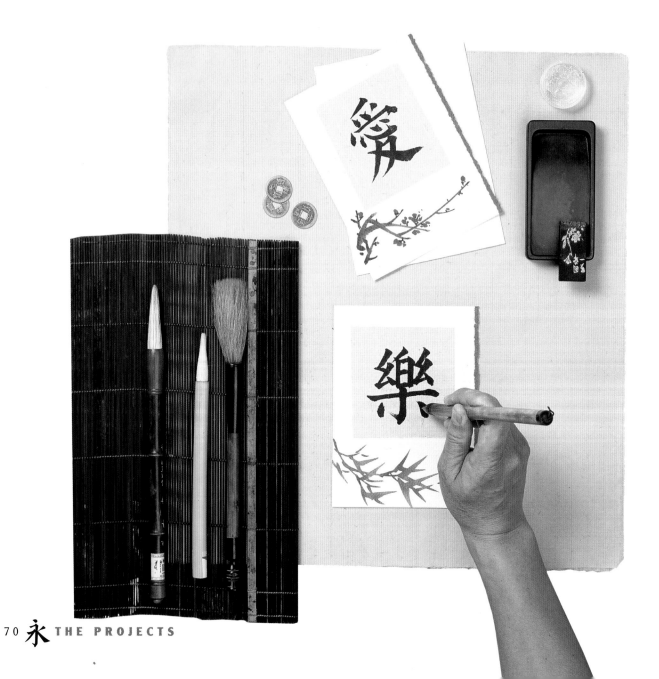

GREETINGS CARDS

To mark a significant occasion or event requires something special.
These handmade cards, each unique, are imbued with meaning and special sentiments.
After the occasion has passed, they can be framed as artworks
or kept as uplifting mementos.

Long Life

Age, and its accompaniment, of wisdom, is revered throughout the East. This is the antique form of the of the age-old oriental wish for a long and happy life. This complex form is now mainly seen only in calligraphy. It is traditionally accompanied with pine leaves.

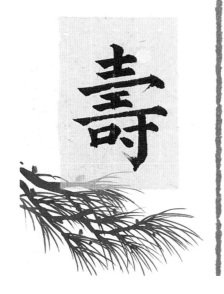

Music and Joy

The simplest eastern greeting loses none of its fervor in this elegant message which is suitable for all occasions. The card can be used for marriage celebrations, birthdays, or for the birth of a child. Bamboo is the accompaniment for this greeting.

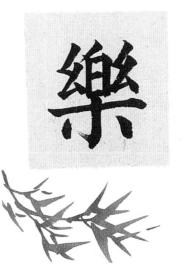

Good Luck

Used to mean "luck at all times", the card can also be sent at New Year. The Chinese New Year takes place in January or February each year at varying times. An enormous celebration in Buddhist cultures, festivities take place worldwide over three days.

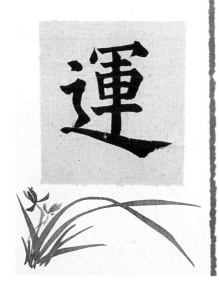

Love

Symbolically accompanied by the flowering plum, the national bloom of Japan and the sign of fertility, beauty and romance, this single character is imbued with the essence of romantic and platonic love.

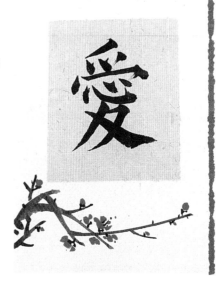

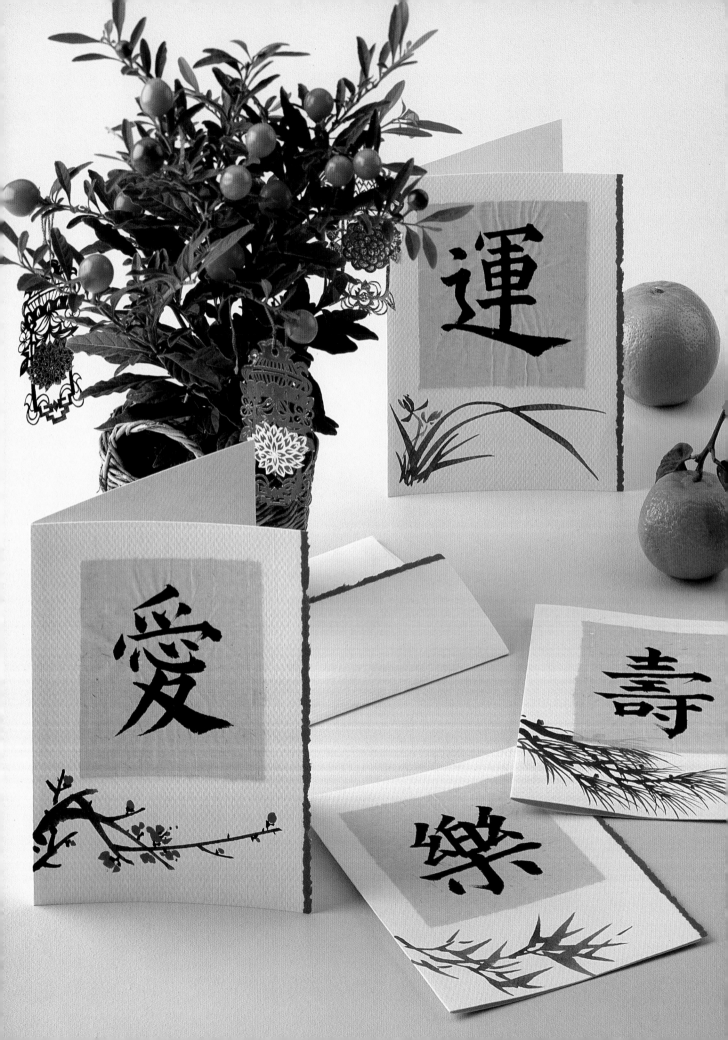

individual card

By creating a card for a loved one you can share the auspicious greetings with them. As you create the cards, try to match the decoration to the greeting; the Music and Joy card illustrated here is partnered with its traditional accompaniment, the bamboo spray. Work on a piece of calligraphy paper that you will then attach to the card, or work directly onto the card.

materials

black and red ink
brush
calligraphy paper
blank greeting cards
seal
spray glue

1 Music and Joy The first strokes for Music and Joy are a small left aside followed by a complete box.

2 Insert the four repeated radicals on the left, working carefully, but lightly over the paper.

3 Repeat the section of the character from Step 3 to the right of the box.

4 Complete the character with the long horizontal, vertical and two dots to either side.

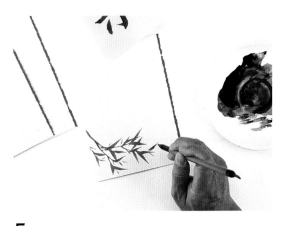

5 The perfect illustration to go with Music and Joy is the further inspiration of a spray of bamboo leaves.

rose petal
talisman

As with all aspects of nature, flowers are very important in Chinese tradition. The rose is associated with all four seasons. Here, a beautiful hand-made rose-petal paper is decorated with the character for Spring, bringing good wishes to a friend or relative as nature is reborn. The second project to use this iconic character, the talisman can be used in the home as the New Year approaches. The delicate colours of the paper contrast with the strong lines of the black ink.

This project could also be made using a variety of different decorative papers, or by decorating a plain paper with the flower associated with a particular season; peony for spring, lotus for summer, chrysanthemum for fall and plum for winter.

Grass signifies energy, so by using grass paper for your calligraphy you could create an energizing, life-giving talisman, which would be especially appropriate to celebrate the arrival of summer or to revitalize someone during the winter months.

By adding a loved-one's name to the character for a season you could create a talisman that could be used to celebrate a birthday (see page 114–120 for popular names reproduced in calligraphy characters).

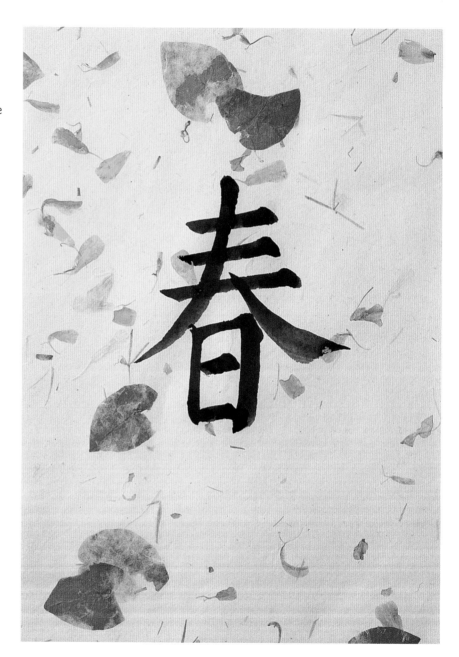

materials
sheet of rose-petal paper
brush
ink

1 The strokes of the character should be written in the correct order. Begin with the three horizontal strokes, starting with the shortest stroke at the top.

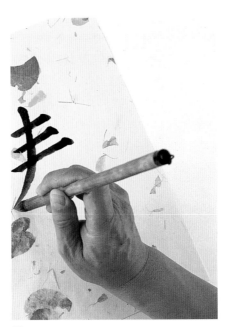

2 This is followed by an aside stroke, curving away from the top stroke.

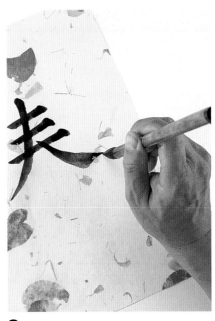

3 Next, starting just above the lowest horizontal, paint a right falling stroke.

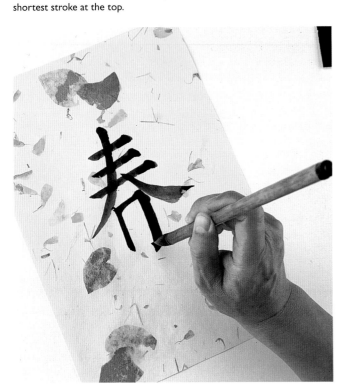

4 The box is then drawn starting with the vertical stroke, followed by the top horizontal and right side, which is done as one stroke.

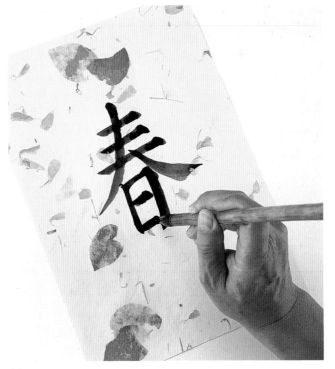

5 The small inner horizontal stroke comes next, and the whole character is closed with the bottom line of the box.

purple talisman

A variation on the theme of Spring, shown on the rose-petal talisman on page 74, this dramatic talisman is created for hanging in the home. No Eastern residence is complete without a series of written messages, displaying either wishes for the New Year, greetings to visitors, lines from prayers, or simply inspiring single sentiments. These talismen have acquired their almost iconic status largely due to the precious nature of the calligraphy that creates them. Indeed the key to the success and value of a talisman relies on the beauty of the calligraphy itself, the movement of the energy through the character, its mood and feeling, and the play of the strokes of the character within the area of the paper.

materials
purple card
gold calligraphy ink
water
brush
seal

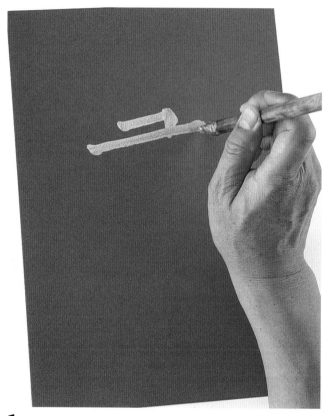

1 Before starting the project, practice the horizontal stroke using the gold calligraphy ink on absorbent rough paper. If necessary, dilute the ink with a few drops of water to make it easier to work with. When you are ready to start, create the first, horizontal stroke, adding a small hook at the right. Create the second, longer horizontal stroke.

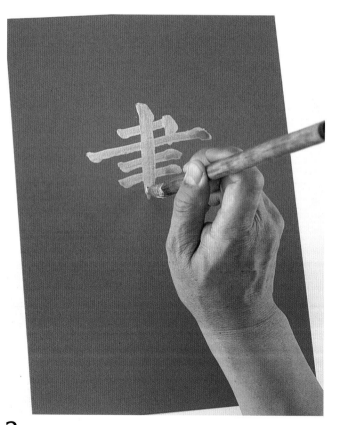

2 Create two horizontal strokes, each the same length as the first stroke. Now draw the vertical stroke through the center of the four strokes. Finish this top section with a further short horizontal stroke.

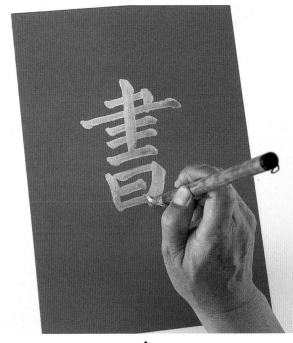

3 As you move on to create the base of the character, bear in mind that you should always create a square by drawing the left vertical stroke first. Follow this with the horizontal, which turns into a bend to the right.

4 Now draw the shortest horizontal that runs two-thirds of the way across the inside of the square. Finally, complete the square shape with a short horizontal.

couplets

The couplet, always shown as a pair, is a pair of hangings for the home that combine the best of literature and art. The creation of couplets, an important Chinese art form, evolved from the writing of poems. Both poets and calligraphers explored this form to create a blend of writing and calligraphy, that works to show the best of both beautiful words and the visual artistry.

Couplets naturally have two lines on each panel, but there is no limit to the word number. Style rules are strict: both lines must contain the same number of characters, verbs, and nouns, as well as concepts in matching pairs.

Couplets are often used to commemorate a special event or for inspiration in daily life. The text can be historical, extol the beauty of nature, or provide apt sayings for the home. Couplets can be written on paper, or carved on wood or stone. The best places for hanging couplets are beside a door, by the porch, in the study, or on either side of an important painting. Any pairs of objects can provide the frame for a couplet, or even two sides of the same artifact. The calligraphy can be in any style, but should be kept constant for both couplets. *Inspirations* (see page 112) provides further suggestions for couplet text.

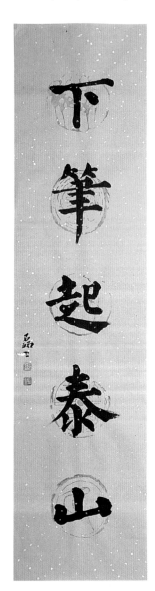
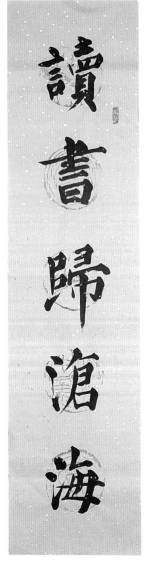
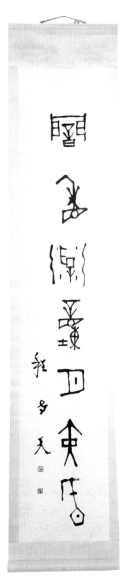
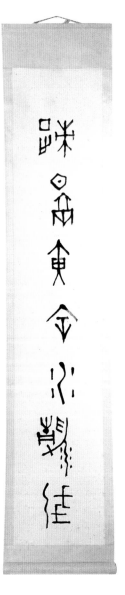

materials

bookmark (both sections)
brush
ink
couplet paper:
 2 sheets, each 5 ft (1.5m)
long brush for decorating
 (if required)
gold calligraphy paint (if required)
seal

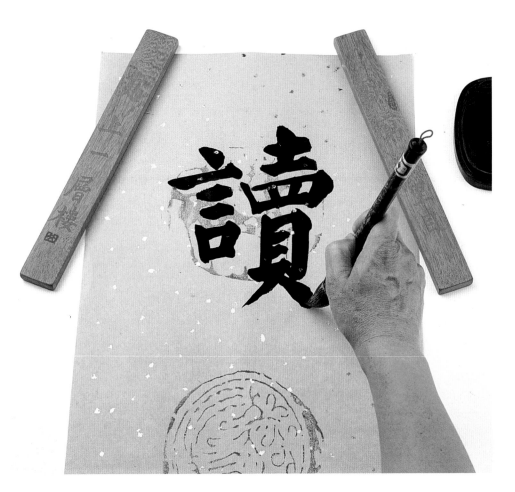

1 The first character on the first line means "reading". The writing sequence runs from left to right, then top to bottom.

2 This character means "flow" and is written from left to right, with the long downward character created last. If required, decorate your finished artworks with gold flecks (see page 65).

Opposite page, left:
This couplet is after Pu Ru, a relative of Pu Yi, the last emperor of China. The first line on the right reads: "Knowledge accumulated from reading is like the confluence of water from rivers that combine and flow into the sea". *The second line on the left reads:* The emotional power of your brush builds a creative force like the Tai Shan mountains emerging from the earth."

Opposite page, right:
This pictographic script represents two sentences of an aged poem about plum blossom. The calligraphy is by Cheng Yutian. The first line reads: "A few shadows falling across a clear shallow stream." *The second line reads:* " A secret fragrance floating in moonlight."

wooden
paperweight

Not only a practical item for the new calligrapher, this two-part paperweight also embodies a spiritual message. Each bar of the paperweight uses one line of a Tang poem by Wang Zhi Huan in which the poet compares his inner and outer journeys, while watching the sunset over the Yellow River as it flows toward the sea. It was at that moment he realized that if you want to see further, you should stand on a higher level, at least in spirit.

Both sections of the paperweight are made of a heavy hard wood, cut to about 12 in (30 cm) in length each, and sanded to a smooth finish. Suitable wood is available from a good home store and can be cut and sanded by hand.

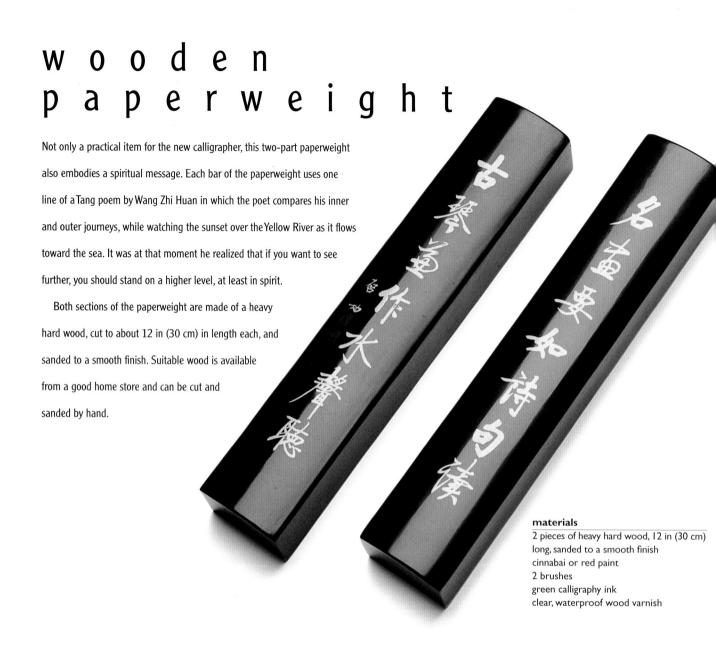

materials
2 pieces of heavy hard wood, 12 in (30 cm) long, sanded to a smooth finish
cinnabai or red paint
2 brushes
green calligraphy ink
clear, waterproof wood varnish

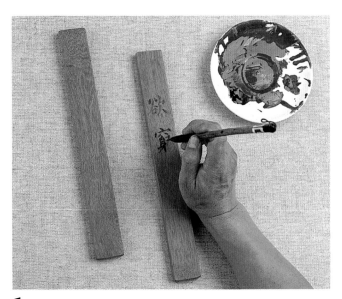

1 Take a moment to work out the spacing of the characters. Work down the first strip, copying each character carefully in seal ink or red oil paint.

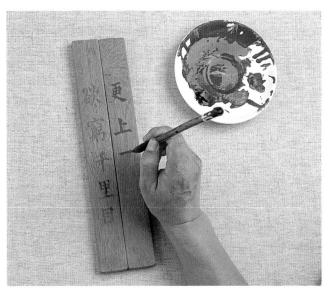

2 Once you have finished the first section, place it parallel to the second section while you work. You can then match the spacing of the characters as you work down the second strip.

3 Use cinnabai or red paint to write your signature (see *Inspirations*, page 114 for name units) on the left hand side of the lower part of the second strip, between the third and fourth characters. Draw the "free seal", a character pattern that you like, to the right and between the first and second characters on the first strip. Finish with a coat of clear, waterproof wood varnish.

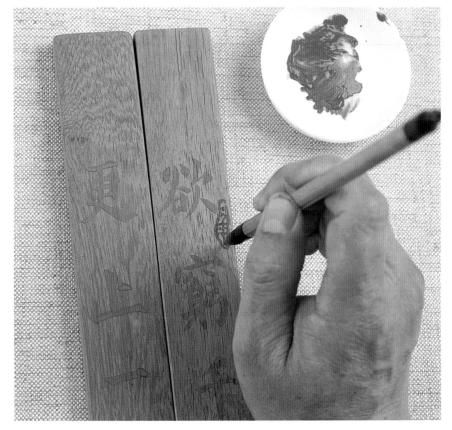

bamboo book

A re-creation of the first type of book in history, this traditional book roll can be displayed, or rolled away for safekeeping. In order to make this project, you will first need to prepare the wooden strips. These should be made of hard wood and cut to equal size with a small hole drilled 2cm (¾in) from each end. You will also need to have prepared and practiced a piece of text that will fit the wooden blanks. This may be a traditional poem or story or something you have written yourself; see page 112 for examples.

materials

ink
brush
seal
string or twine
scissors
prepared bamboo or blank wooden strips
 (available from home stores)

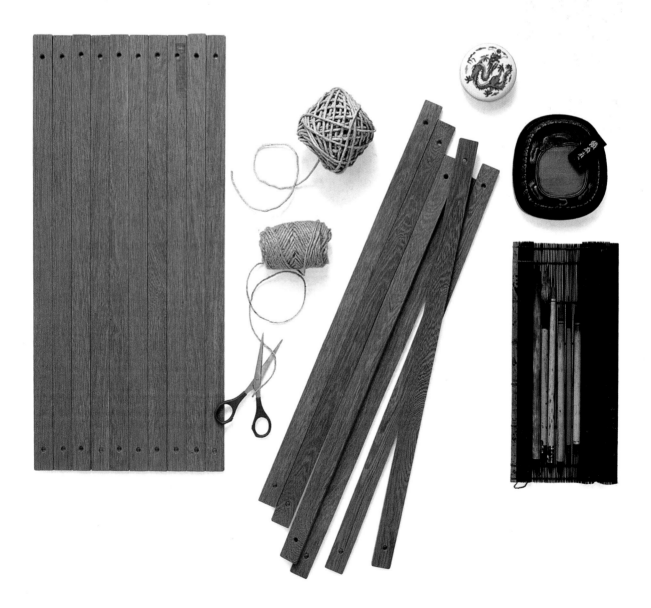

朝陽

忽然半生得悟天機 豁然心胸頓釋凝滯 守株而待其兔一

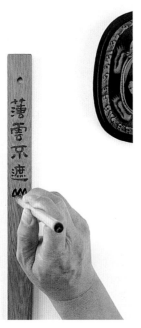

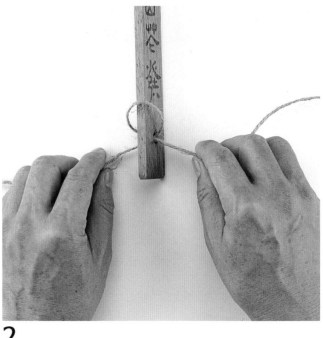

1 The first line

Remember to begin writing at the top right-hand corner of the text and work down the strip to the bottom (see inset). Continue until you have decorated all the strips.

2 Making up the roll

Measure a piece of string at least five times the length of all the strips placed side by side. Making sure you have all your strips in the right order, begin with the final strip of text on the left. Find the mid point of your piece of string and form a loop by threading one end through the hole from above and the other end from underneath.

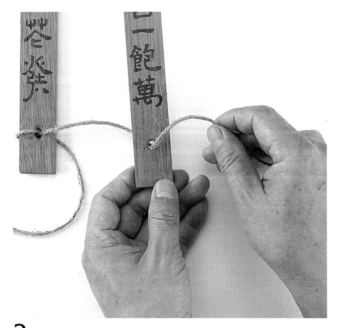

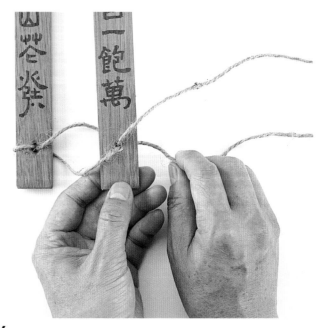

3 Joining the strips

Select the next strip in the sequence (the second to last) and thread the string through the lower hole.

4

Ensure that each half of the string threads under and over the strips alternately, crossing between each strip and through the holes.

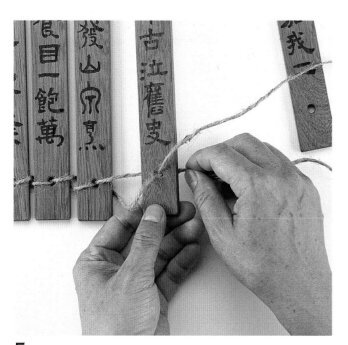

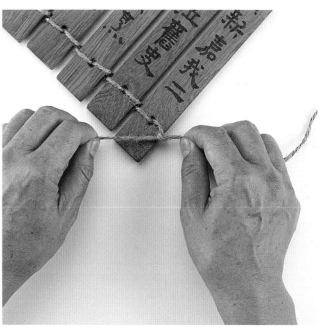

5 Continue joining the strips in the right order using the lower holes. Allow about ³⁄₁₆in (½cm) gap between each strip.

6 Secure the final strip on the right side of the roll (the beginning of the book) with a strong knot. Repeat the process with the upper holes.

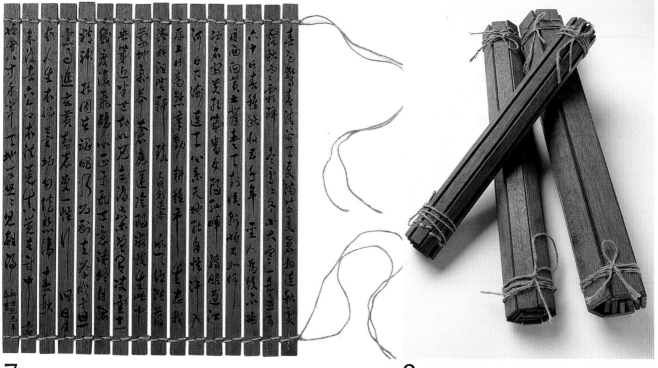

7 Displaying the roll
The roll can now be placed standing up on a flat surface or hung on a wall.

8 Storing book rolls
Begin at the left side and roll the joined strips to the right. The free ends of the string can be tied to secure the roll.

bamboo
place mat

Many everyday objects can be decorated using Chinese calligraphy, such as the table mat illustrated on the opposite page. Suitable bamboo mats are available to buy and are quite inexpensive.

The character used for the decoration is Carefree Cloud, shown in pictographic script. It is drawn in red paint or ink, to emphasize the joyful, happy feeling of the message.

materials
bamboo table mat
sandpaper
red ink
brush
clear wood varnish

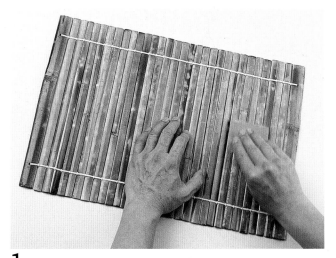

1 Bamboo table mats come ready-varnished. Sand the section that is to be painted to remove the varnish in readiness for the calligraphy.

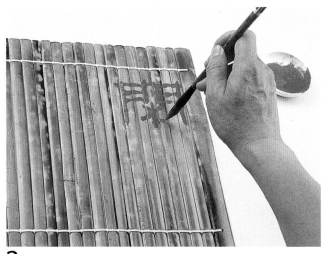

2 Start the character Carefree Cloud with the upper radical, or "gate" followed by the inner part, which represents "wood".

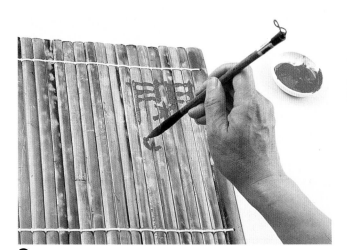

3 Now paint the lower, "cloud" section, of the character.

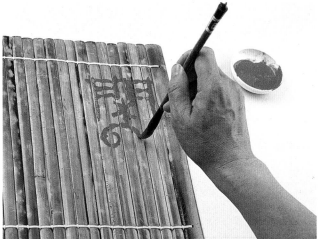

4 This section is made up of a series of curves, rather than one continuous stroke.

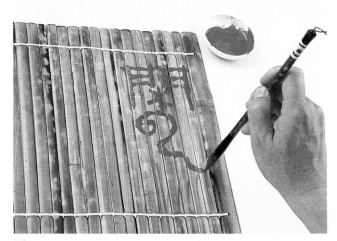

5 Continue down to the bottom of the character.

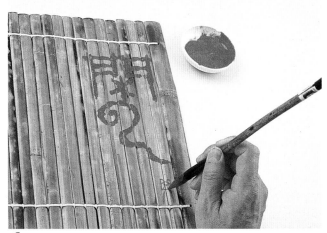

6 Add your signature to the finished mat. Finally revarnish the mat to seal the painting and allow to dry thoroughly.

making a seal

The earliest seals, found in China BCE 2000–3000, were made of clay imprinted with a personal mark. By the Warrior Period (the Bronze Age) bronze, gold, jade, and stone seals were in use, giving great power and authority to their owners. Seals became important objects by which to prove identity. It is difficult to forge a seal as it is cut out of a hard material.

Over time the seals themselves became an art form, with artists owning several seals, depicting not just their personal names, but qualities by which they liked themselves and their work to be known.

The best seals are made from pyrophyllite, known as Qing Tian, from Zhe Jiang Province and Shou Shan from Fu Jian Province. These are types of aluminium silicate, with an opaque white, grey or greenish appearance. Many materials can be, and have been, used for seals, such as metal, jade, gold, ivory, and agate, but they are not easy to carve, being too hard, soft or brittle. For working at home, soapstone, or any soft stone, is ideal for seal-making.

The example shown declares that (I put) "my whole heart into every aspect of my life", but any appropriate message can be used, including your name. The most popular style is Xiao Zhuan, known today as Seal script.

materials
brush
2 chisels, with ¼ in (5 mm) heads
cinnabai paste for sealing, plus stirrer
safety glove
rice paper
sandpaper, 1 sheet rough, 1 sheet fine
calligraphy paper
soft stone block 1 in (2.5 cm) square, 3 in (7.5 cm) high

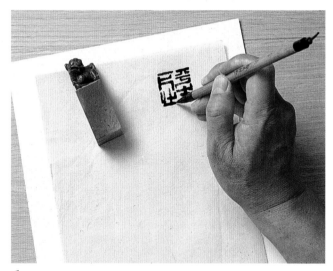

1 Design your seal
Take time to design your seal, as this is the most important aspect of seal making. Ensure that the composition is pleasing, arranging the elements of the character to create a balance of density and space.

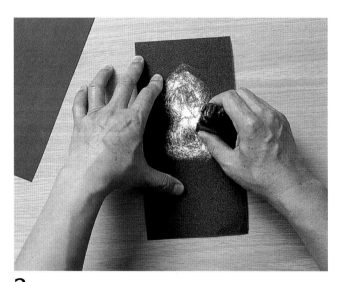

2 Sanding the stone
Place a sheet of rough sandpaper on a hard flat surface, holding it securely. Move the stone over the sandpaper several times in a figure of eight.

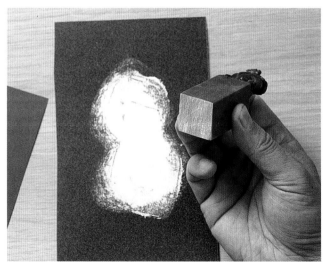

3 Assessing the stone
From time to time, check the base of the stone to ensure that the surface is flat and that all the corners are being smoothed equally.

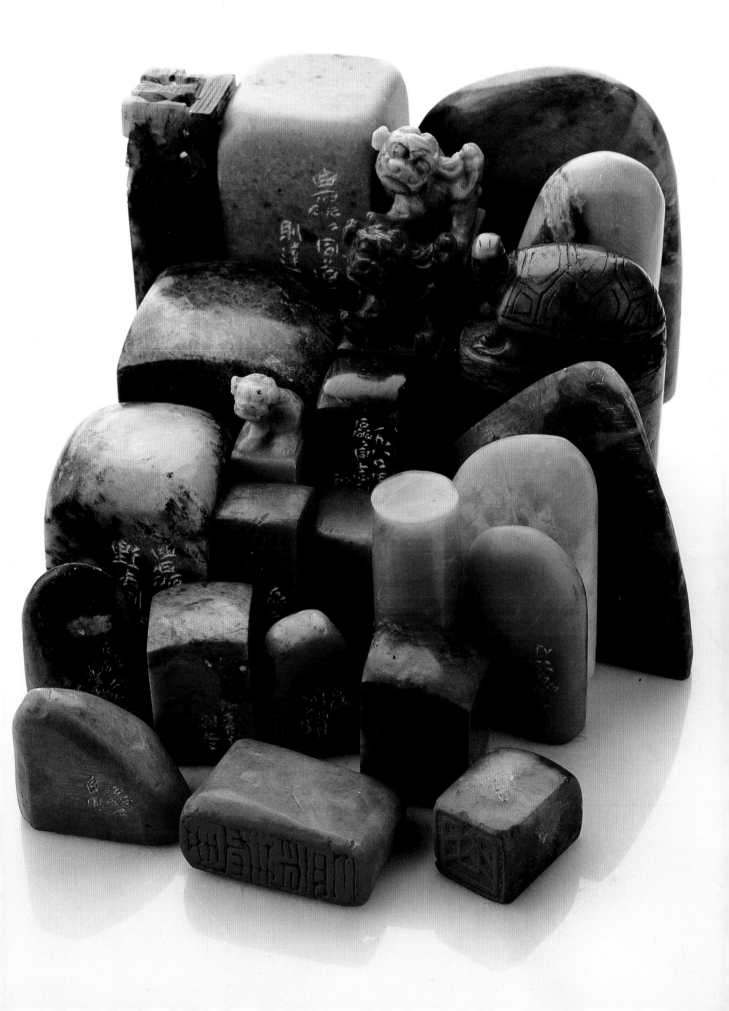

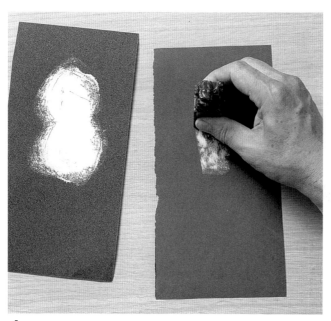

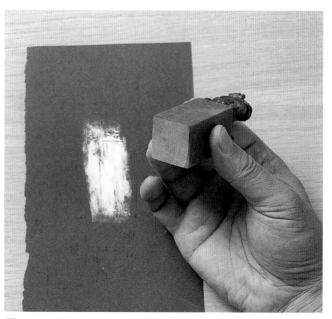

4 Final sanding

Change to the fine sandpaper and hold the stone absolutely flat. Then using a steady, equal pressure, in a single stroke push the stone up the paper.

5 Check the stone

Check the stone to see that it now has a smooth, flat base.

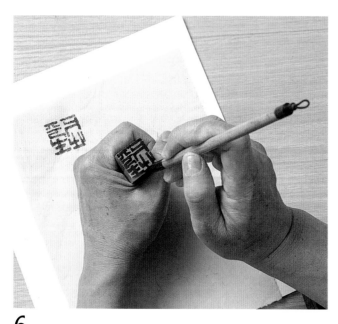

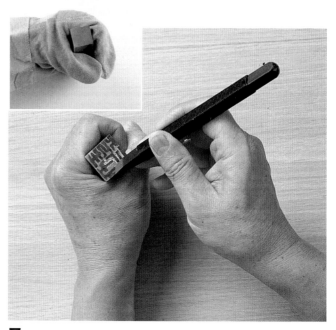

6 Copying the design

The design will have to be carved back to front in order to appear the right way round when it is printed. You can either follow the image in a mirror, or recreate the small design on a sheet of rice paper so that the design shows on the reverse. Turn the paper over and copy the image onto the stone.

7 Safety when carving

Always place the seal in a special holder or wear a safety glove (see inset). The photograph shows the very experienced author holding the seal in his bare hands. As a beginner you must not attempt this. The knives are very sharp and the stones are brittle and could break into sharp pieces.

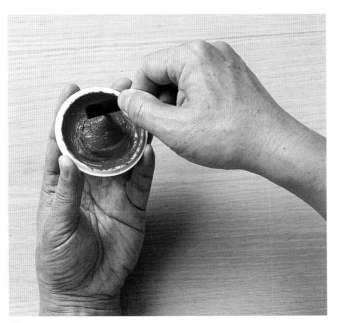

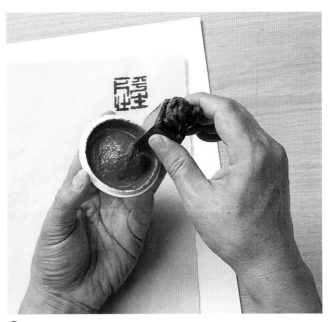

8 Preparing the seal printing paste, Yin ni

This is made with cinnabai, reed flour and castor oil. When you buy the printing paste you should be provided with a stirrer made of horn or plastic. Before using the printing paste, smooth the surface in one direction until you have formed a ball. This aligns the fibres and prepares the paste for printing. Do this every couple of months to keep the paste ready to use.

9 Applying the printing paste to the seal.

Dab the seal very lightly on the printing paste, ensuring the raised parts are completely covered.

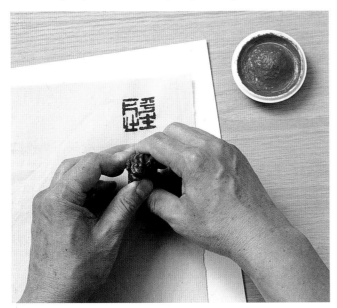

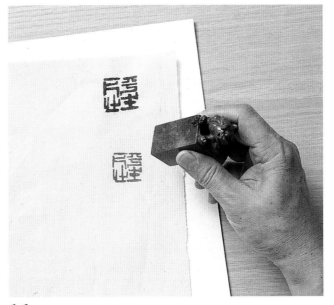

10 Printing the seal

Place a magazine or telephone directory on a hard flat surface and your artwork on top of the magazine. This provides just the right amount of firmness and cushioning. Consider carefully where you want to place your seal then press down firmly.

11 Lifting off the seal

Hold your work down with one hand and gently remove the seal with the other in a single movement, taking care not to smudge or blot the print.

calligraphy on stone

Calligraphy on rocks and stone is an extremely important part of Chinese cultural heritage and can be seen today on every famous holy mountain, such as Tai Shan or Ermei Shan. It can also be found in celebration of beautiful scenery such as that at Huang Shan. Momentous events have been recorded for posterity, as have the deeply personal expressions of artists painted directly on to natural stone outcrops, cliff faces or specially erected monoliths. The characters would then be carved by master masons. It is possible to enjoy examples of rock carvings in the form of stone rubbings, another specialist skill. Books of stone rubbings have become treasured art works in their own right; your own calligraphy stone could be the start of a collection.

PAINTING ON STONE

materials
ink
brush
suitable stone or pebble;
 (available in bags from home stores)
clear waterproof masonry varnish

1 The many meanings of Shan, the character on the stone, include all the qualities that are considered to contribute towards perfection and right living, including kindness and charity to others, as well as personal and spiritual improvement. Find a stone in your garden, or buy one from a garden center, wash it thoroughly and allow it to dry. Settle the stone into a padded working surface, so that it does not move. Prepare the brush and ink and then begin with the two dots on top, then create the horizontal stroke.

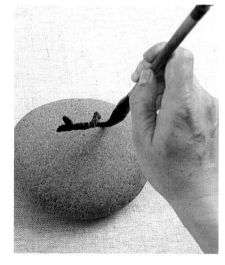

2 Next, keeping the stone still, follow with the second horizontal stroke.

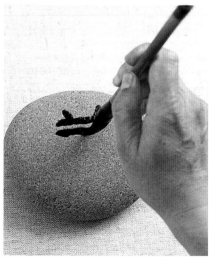

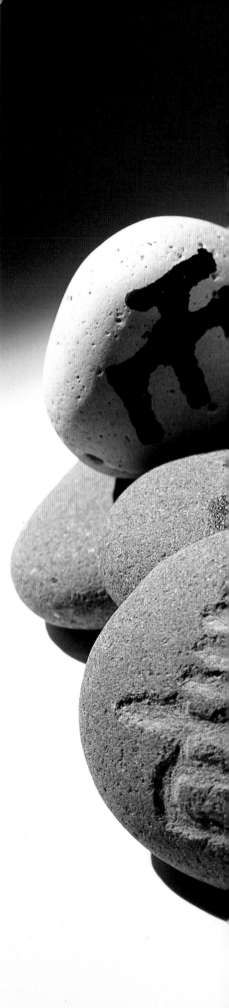

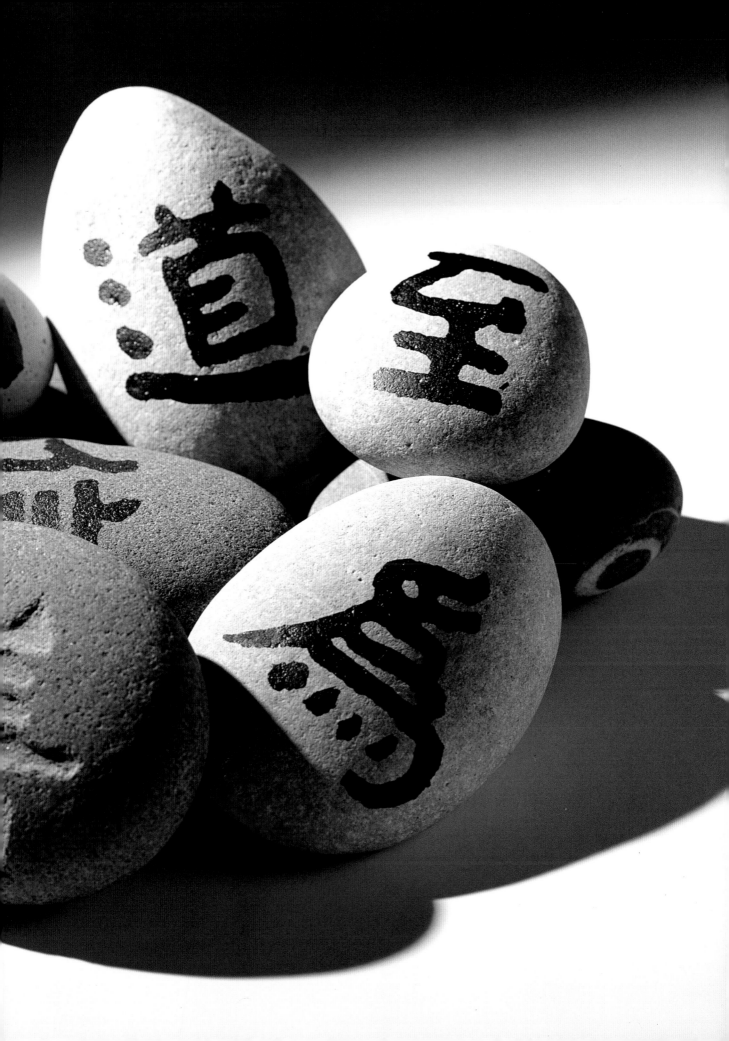

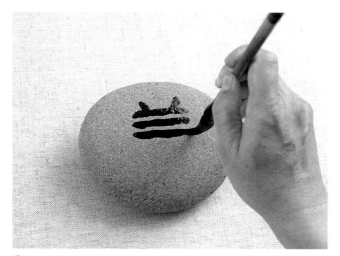

3 Create the third horizontal stroke.

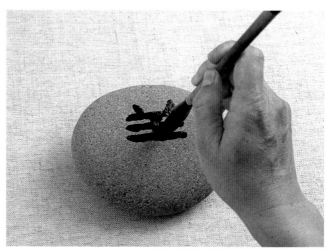

4 Write the short vertical stroke through the center of the three horizontals.

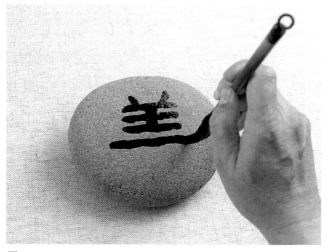

5 Keeping the stone straight, stroke the longest horizontal.

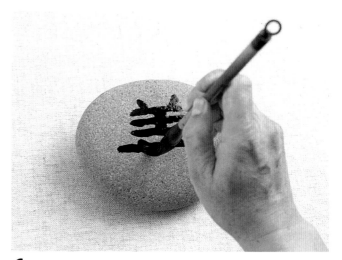

6 Add two dots to the longest horizonal stroke.

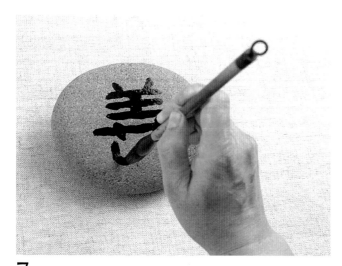

7 To finish, create the box in a single stroke. First form the left vertical, followed by the top horizontal and right vertical.

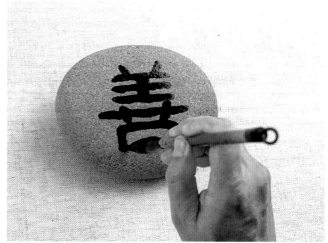

8 Add the closing base horizontal. Allow to dry for 24 hours, then coat with clear, waterproof varnish.

materials

sharp pointed chisel with ¼ in (6 mm) blade
flat chisel with 1 in (25 mm) blade
grooved/multi-pronged chisel with sharp tip
wooden hammer/mallet
goggles

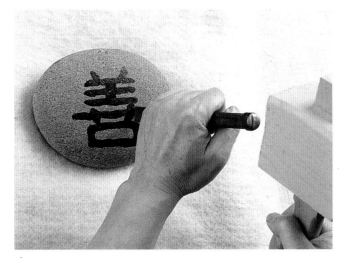

1 Once you have painted your design (see pages 92–93), use the pointed chisel or a corner of the flat chisel to cut the outline of the character. Remember that the artistry is in the writing as well as the carving.

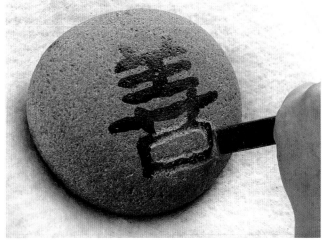

2 The multi-pronged chisel is then used to cut out the part between the outlines, carefully chipping away to create grooves about ¼ in (5 mm) deep.

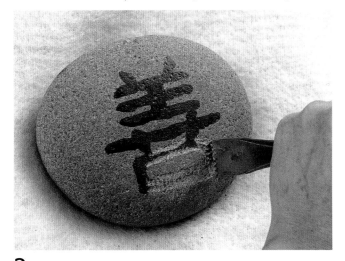

3 **Clearing the grooves**
Using the flat chisel, remove the stone from between the grooves.

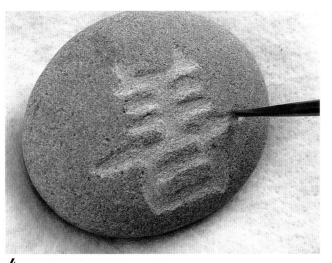

4 **Finishing off**
Carefully work your way around the whole character until the carving is complete.

t e e s h i r t

Decorating fabrics with calligraphy is increasingly popular; try the design of your choice on clothing, curtains, and cushions. In all cases, use fabric paint and follow the manufacturer's instructions for preparation, fixing, and washing.

Before painting, ensure the fabric you are using is flat and stable. For the tee shirt, a sheet of cardboard has been cut and inserted to separate the two layers, stretch it and provide a flat surface to work on. Single layers of fabric can be held in place on a board with masking tape.

The character chosen for this example is 'Qi', with multiple meanings referring to "life force", "energy" and "vitality". Note that the movement given to the character by the wearer of the tee shirt would aptly demonstrate the meaning of the word. To give added vitality, also reflecting the essence of the character, a flowing, cursive style is used, with the brush moving freely and continuously. You might like to practice it on paper before painting on the fabric.

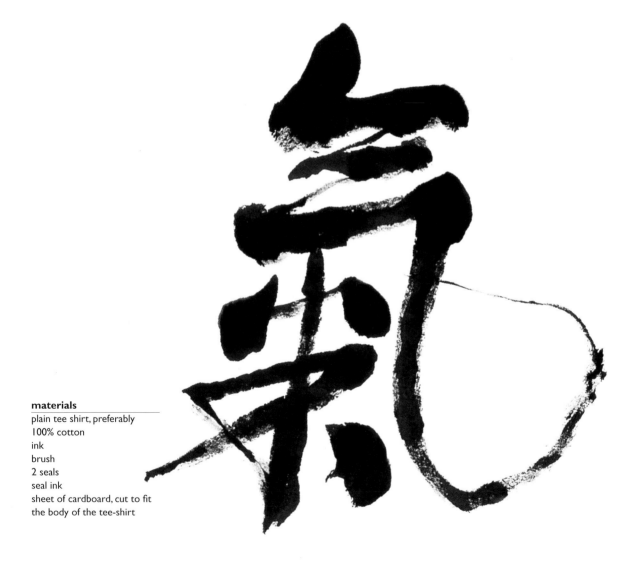

materials
plain tee shirt, preferably
100% cotton
ink
brush
2 seals
seal ink
sheet of cardboard, cut to fit
the body of the tee-shirt

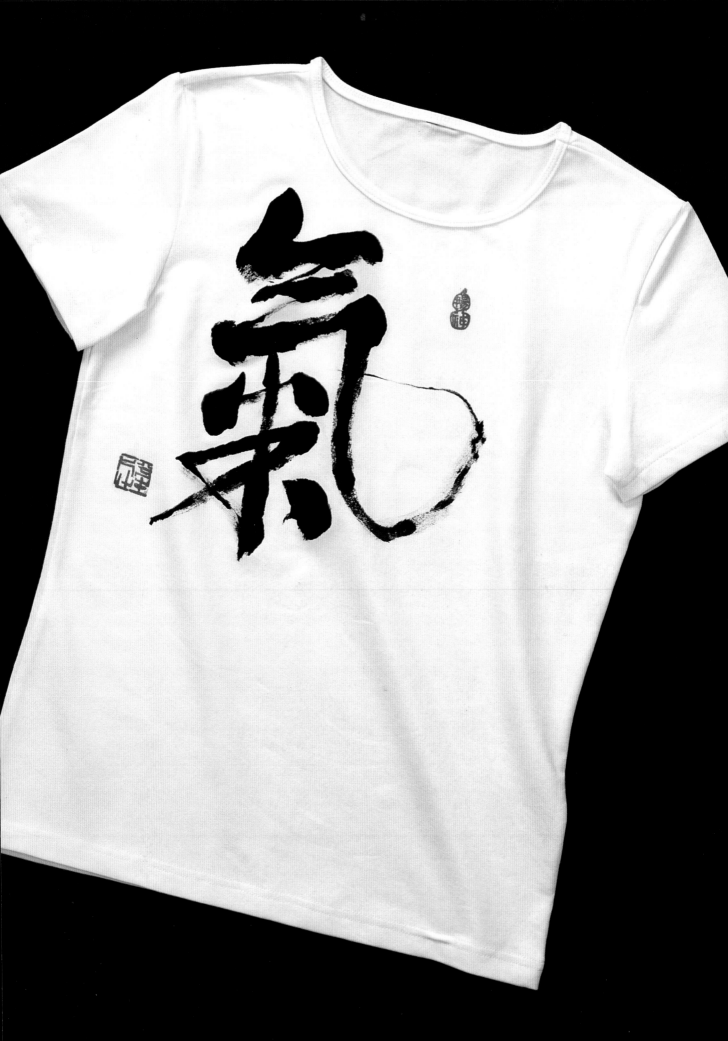

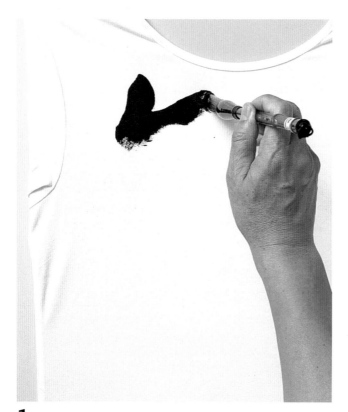

1 Begin with the top left aside, connecting it to the horizontal. After making the horizontal, lift the brush, but don't take it off the fabric completely.

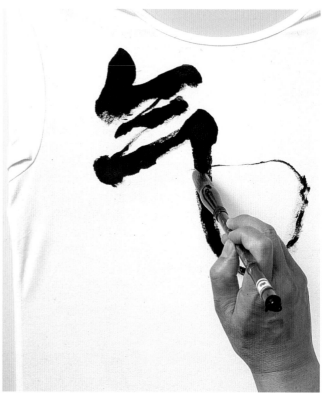

2 Lightly connect to the second horizontal and follow on in the same way to write the next two-stage radical, made up of a horizontal and vertical stroke combined. Lengthen the down stroke, a hook into a flourishing loop.

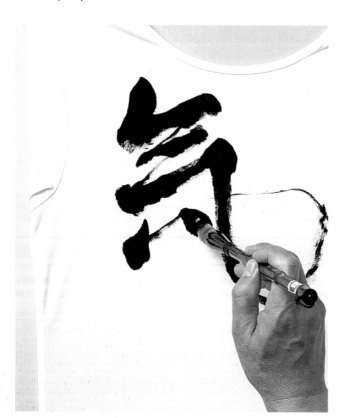

3 The brush comes off the fabric briefly, but the energy flow continues to the left dot.

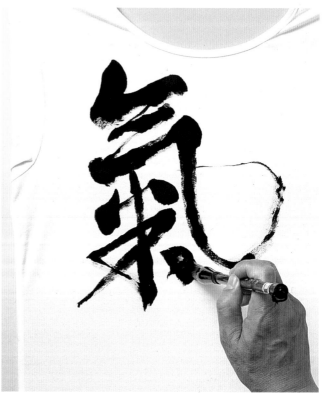

4 Move across lightly to make the right dot, then on to paint the vertical. Lift the brush, but maintain contact up to the next combined horizontal and aside stroke. Keeping the energy going, lift off the brush and finish with the lower right dot.

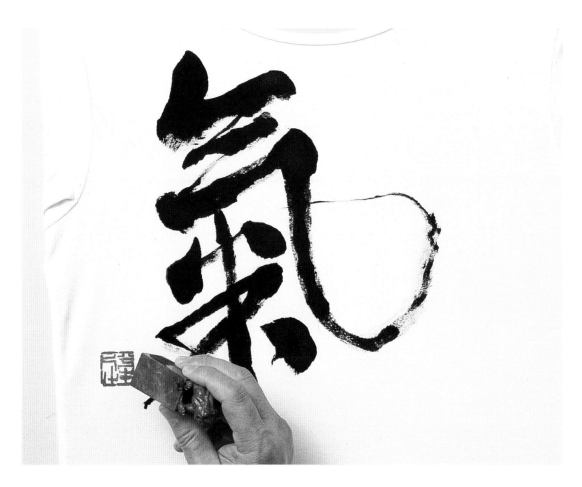

5 Place your seal near the lower left section of the character. You can use seal ink for this as it is oil based and won't run.

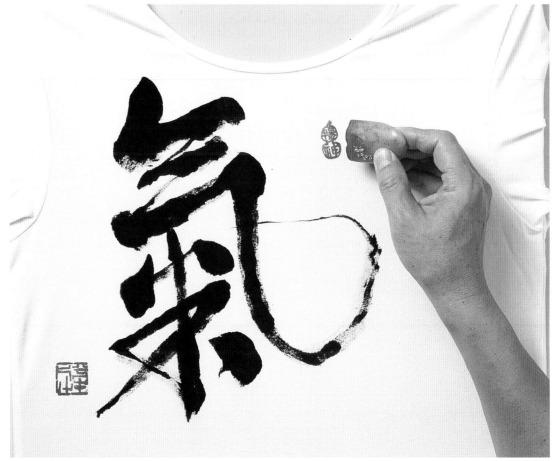

6 Another free seal can be placed to the top and right of the character.

p a p e r c u t t i n g

In China, papercutting is a folk art with a very long history. It is a skill that has been passed down from generation to generation, carried out in a spirit of joy and exuberance. Practiced all over China, paper cuts are used as decorations on windows, ceilings, walls and mirrors, particularly for celebrating Chinese New Year in January or February, moving house and at wedding celebrations.

In the past, used as window decorations, paper cuts would be pasted on paper stretched over a wooden window frame. Nowadays, glass panes have taken the place of paper, but the paper cuts are still used as decorations, often pasted on each of the individual panes that make up a traditional window. In the bedrooms of newlyweds, erotic paper cuttings are pasted to the ceiling – wishing the couple happiness and many children!

Relics from the distant past show that in many remote areas such as Shan Xi, 4,000 year-old artifacts have inspired papercutting design in the present day. Apart from decorations in the home, the distinctive design characteristics of papercuts are put to a wide range of commercial and other artistic uses. Applications include individual, small-scale craft uses, such as stencils for printed or sprayed color, or on pottery and fabric, theater design and animation, and templates for large-scale graphic and commercial design.

Any design can be adapted for use in paper cutting, including calligraphic characters. On the facing page, the character meaning "good fortune, blessing or happiness" is shown in four different styles each with a different decorative border depicting circles, blossom, butterflies, and peonies.

Here, papercutting stencils have been created using the templates on page 104 and transferred for use onto a set of white linen napkins.

materials
papercutting paper (available from specialist stores)
scissors with sharp-pointed blades (Chinese-style scissors are very suitable)
small stapler
1 washed and ironed white linen napkin per design
1 canister or scarlet spray paint for fabric
spray glue for paper and wood

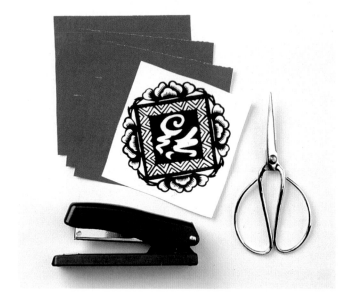

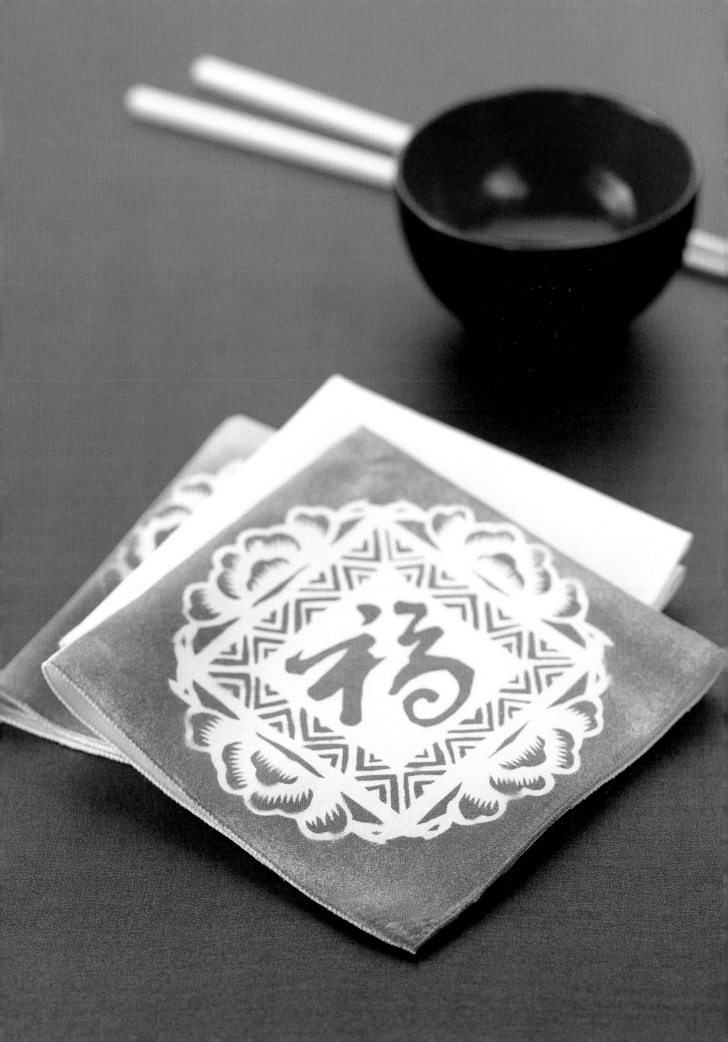

1 Make your own design or use a photocopy of the templates of pages 104–105. Staple your design to the papercutting paper. This comes in many colors, but the most popular is red. If the paper is thin, staple two or three sheets together. Begin with the inner parts of the border. Make a fold in a blank area and make a small cut.

2 Open out the paper, insert your scissors into the snip and cut out the shape. All parts of the design must be connected to each other so that they don't fall out.

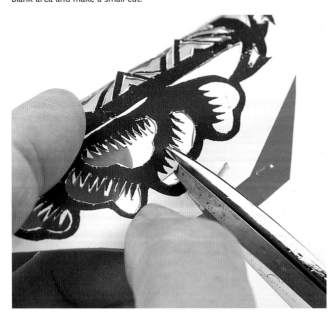

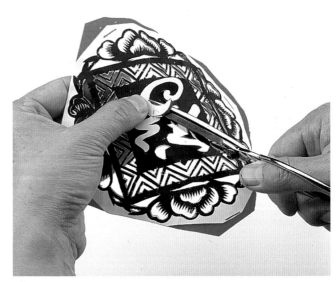

3 Continue cutting out the shapes. Where there are areas of detail, such as the saw tooth design shown, cut out the out main blank area first as this will make it easier to cut around the individual "teeth" of the designs.

4 Then cut out the central shape of the character.

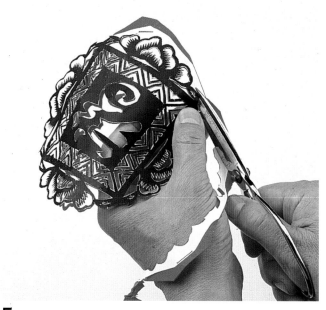

5 Finally cut out around the outline. Only cut the outline at the end of the cuts, as otherwise you will have cut away the blank parts with the staples holding the design to the paper.

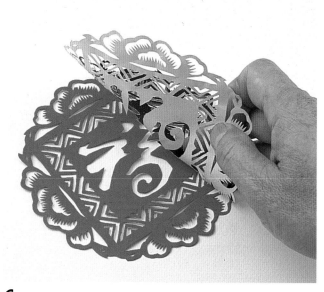

6 Peel off the design revealing your paper cut(s). Do this slowly and gently, make sure the sheets do not stick together or tear. The papercut is now ready for use.

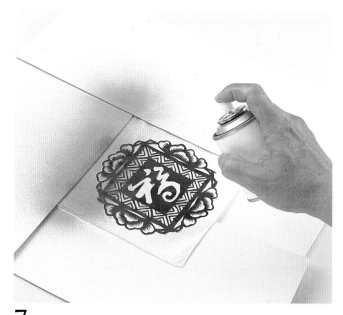

7 First coat the back of the paper cut with removable spray glue before placing on the surface you want to decorate, such as a fabric table napkin, then spray with paint.

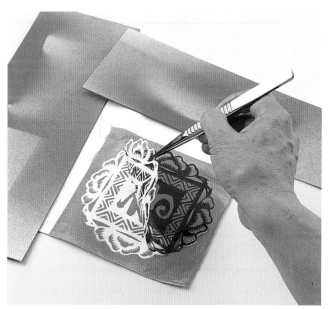

8 Remove the paper cut with tweezers. If you are careful at this stage you can use the same paper cut several times.

templates

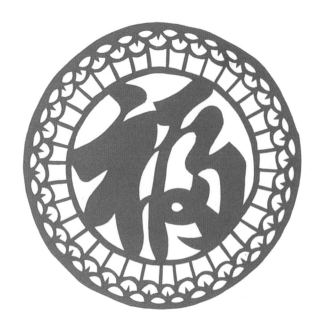

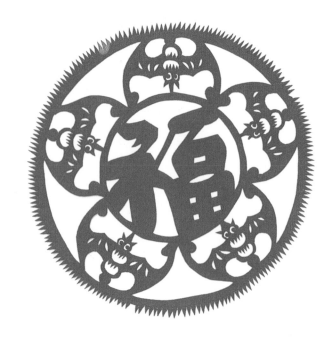

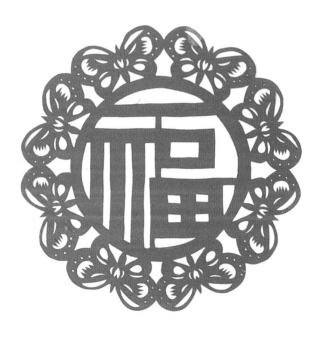

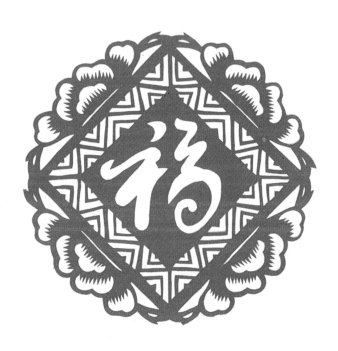

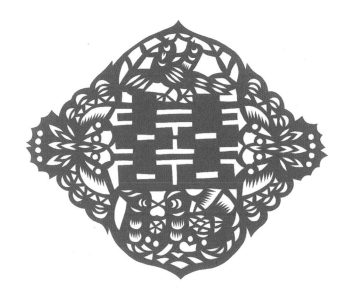

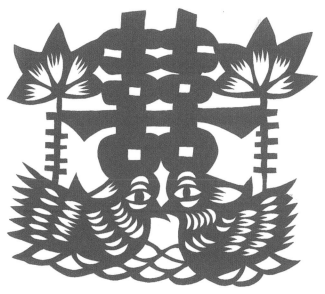

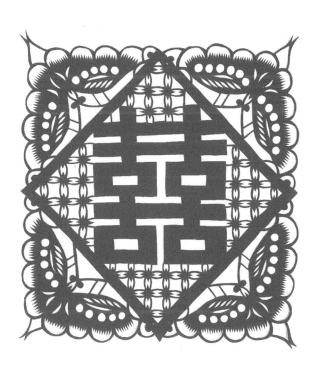

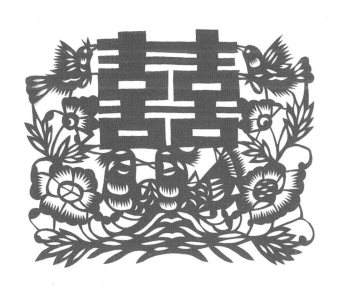

m o u n t i n g

Mounting a finished work is an integral part of creating a Chinese painting or piece of calligraphy. Applying ink to rice paper or silk distorts the fibres, making the surface crinkled and uneven. The traditional method of mounting not only re-stretches these materials but also brings out all the subtleties and luminescence in the ink and colored pigments, which are not apparent beforehand.

The almost magical quality brought to a piece of work by mounting is recognized by the terms given to the paper applied directly to the back of the artwork. One description is hun zi meaning "soul", and another is ming zhi, or "life paper", which brings the art work to life.

Having mounted the silk or paper on a paper mount there are many ways in which a work can be enhanced. You could add a silk border or make it into a hanging or hand scroll. However, the project here shows the simplest mounting process, after which the work can be window mounted with mounting board and put in a frame.

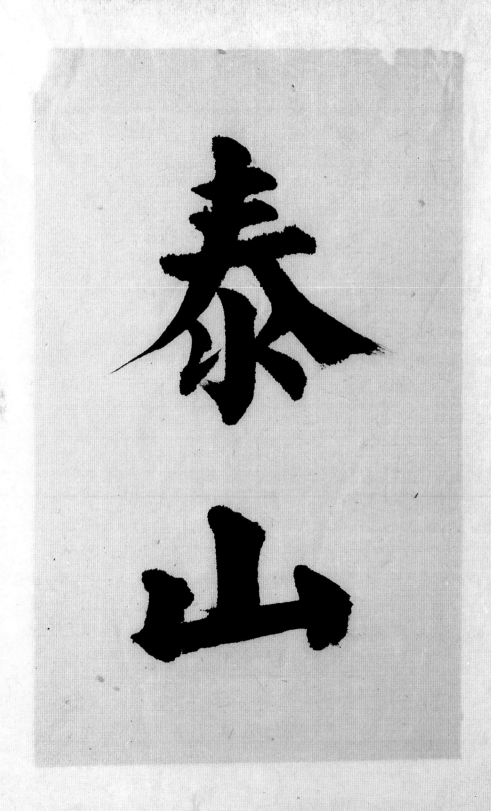

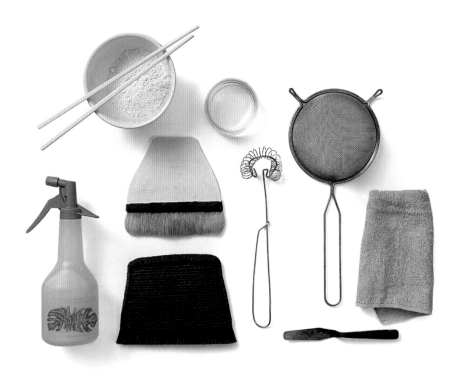

materials

plain flour
bowl
sieve
whisk
soft brush
hard brush
water spray

palette knife
small cotton towel
sharp kitchen knife
two pieces of board, one with an
unabsorbent finish to work on and
the other propped vertically for
drying the mounted work.

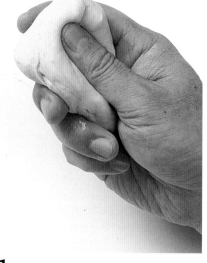

1 Making the dough

Mix the flour with water and knead into a
smooth pliant dough. Cover with a damp cloth
and leave for an hour for the flour to absorb the
water completely. Fill a bowl with water.

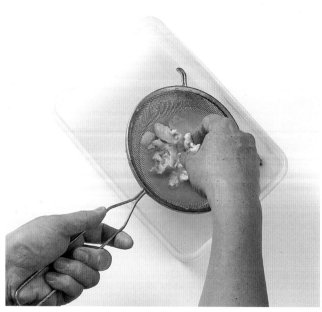

2 Washing out the gluten

Put the dough in the sieve, and wash it to remove the gluten. Discard the
retained gluten. Bring the remaining liquid to the boil, pour into a bowl,
cover and allow to cool overnight. Remove the resulting skin before use.

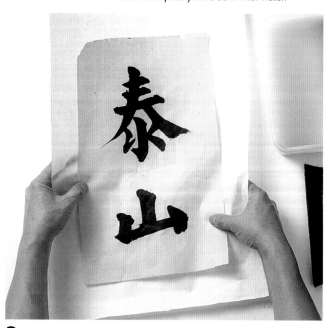

3 Preparing the backing paper

The backing can be made of the same type of paper as the artwork, or if the
calligraphy has been created on silk, rice paper, or grass paper may be used.
Allow at least 1½ in (3.75 cm) all round the backing sheet. Roll the sheet up.

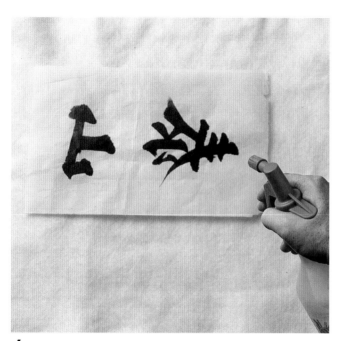

4 Dampen the artwork

Lay the artwork face down on a piece of fabric and dampen the back lightly by spraying evenly and gently all over with clean water.

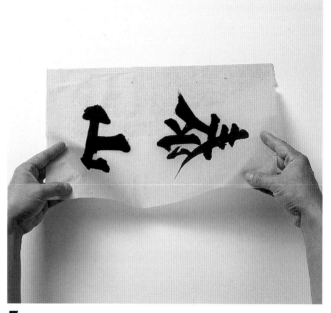

5 Lifting the artwork

The dampened art will now be very delicate, so lift it carefully with thumb and forefinger on top and the other three fingers of both hands, supporting the piece underneath and place face down on the unabsorbent board. Do not attempt to pick up the artwork just between finger and thumb.

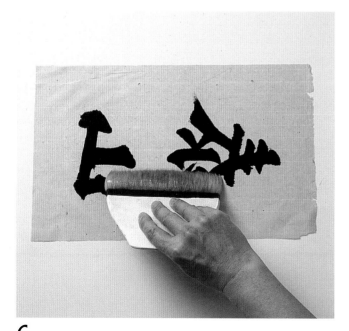

6 Applying paste to the back of the artwork

Using the cooled paste and the soft brush, cover the piece with the paste, gently working from the center outwards. To ensure that all parts are covered, begin by applying the paste downward and then upward.

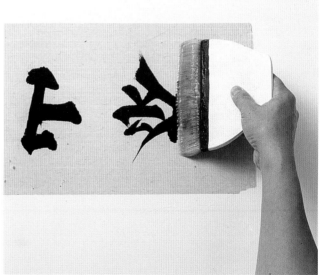

7 Re-applying paste

Work from the center out, finishing with diagonal strokes to the corners. Repeat steps 6 and 7 once more. To ensure that the paste covers the back evenly, work in smooth strokes from side to side and then up and down.

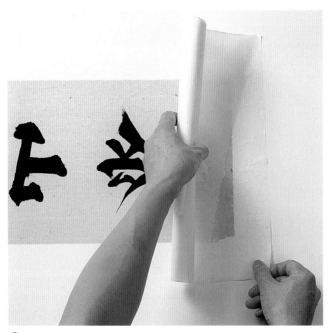

8 Placing the backing sheet
Take the rolled backing sheet and carefully place the bottom right corner of the backing sheet at least 1½ in (3.75 cm) from the corner of the artwork.

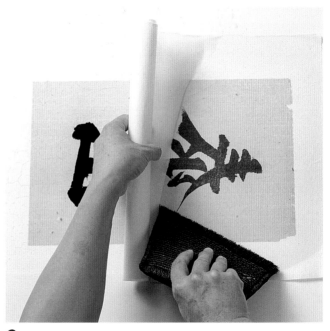

9 Applying the backing sheet
Using the stiff brush, work with diagonal herringbone strokes, while unrolling the backing sheet over the artwork. If you wish to apply a second backing sheet, repeat steps 6 to 9.

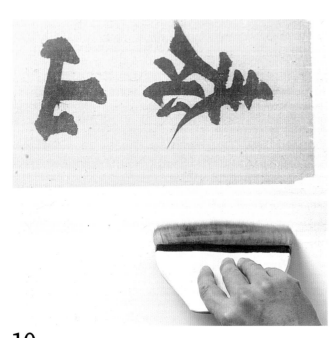

10 Pasting the backing sheet
Using the soft brush, apply paste to about ½ in (1 cm) around the edges.

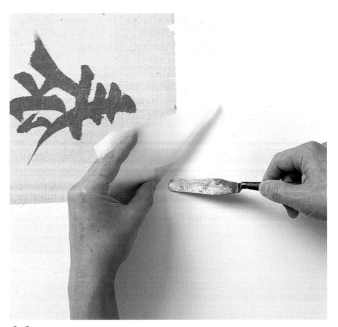

11 Lifting with the palette knife
Lift the bottom right corner of the artwork with the palette knife, ensuring that all the layers come up off the board together. Carefully peel up the mounted work with your left hand.

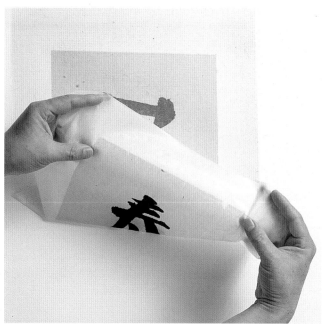

12 Lifting the mounted work

As the top right corner comes up, take that with the right hand and, with both hands, peel the rest of the mounted work off the board. Be very careful to avoid tearing your work at this stage.

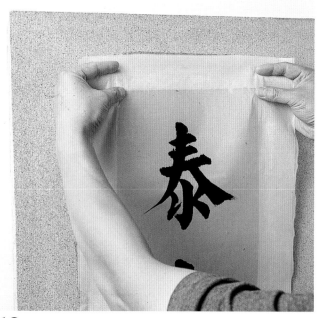

13 Using the drying board

Take the mounted work to the vertical board with the front of the work facing away from you.

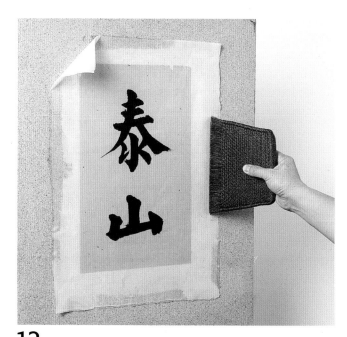

13 Attaching the work to the drying board

Attach the edges of the mounted work to the board. Leave one corner open to blow a puff of air between the work and the board. Seal the corner. Leave for at least two days to ensure it is properly stretched and dried.

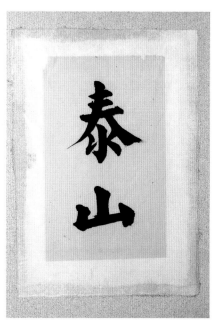

14 Cutting off and window mounting

When the mounted work is completely dry, cut it off the board with a sharp knife leaving a ¹/₂ in (1 cm) border. Turn over. The work is now ready for window mounting and putting in a frame.

inspirations

The wealth of culture from China's long history offers the calligrapher today a wide range of inspiring poems, phrases, and proverbs for all occasions. In keeping with the traditions of brush writing as an almost sacred occupation, and calligraphy as art, you can use the calligraphy on pages 121–126 as variations on each of the projects in the book. You can also choose to personalize your project with one of over 100 male and female names listed on pages 114–117, either for you or for a loved one.

names in Chinese calligraphy

The act of creating a gift for someone you care about, using the symbolically and spiritually significant forms of Chinese calligraphy, is always a rewarding experience for both the maker and the recipient, but when your gift is personalized with the recipient's name it becomes a truly thoughtful, unique gesture. The names are reproduced here in simple Standard-style script so they are all straightforward to copy

This section demonstrates how to apply the calligraphy techniques you have already learnt to forming names, as well as providing a comprehensive list of over one hundred of the most popular Western names for both men and women used in the past century.

With this knowledge you will be able to personalize any of the projects in this book, from fans to T-shirts to greetings cards inscribed with your friend or relative's name in their favourite colours. You might even like even to make eye-catching place mats for each guest at a celebratory meal, or charming gifts such as a personalized sign for a child's bedroom door. Your work can be embellished using the floral motifs (see pages 71 and 112) and, in addition to this, you can choose a truly personal sentiment from the range of poems, proverbs, and phrases (see pages 121–126).

FEMALE NAMES

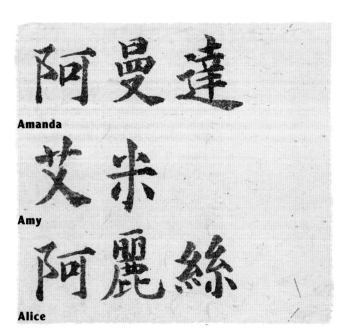

Amanda

Amy

Alice

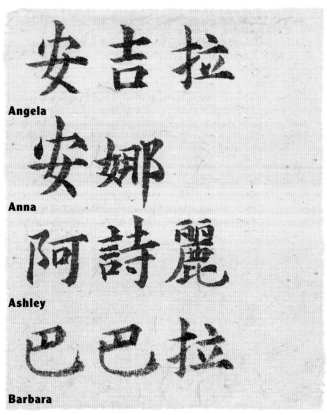

Angela

Anna

Ashley

Barbara

貝蒂
Betty

布里塔妮
Brittany

卡羅
Carol

凱瑟琳
Catherine

辛西婭
Cynthia

黛伯拉
Deborah

戴安娜
Diana

唐娜
Donna

多羅西
Dorothy

伊麗莎白
Elizabeth

埃瑪
Emma

弗洛拉
Flora

弗朗西絲
Frances

喬吉娜
Georgina

海倫
Helen

英格麗德
Ingrid

珍
Jane

詹妮弗
Jennifer

傑西卡

Jessica

瓊

Joan

朱迪思

Judith

凱倫

Karen

凱思琳

Kathleen

金伯莉

Kimberley

洛倫

Lauren

琳達

Linda

麗莎

Lisa

路易絲

Louise

瑪格麗特

Margaret

瑪麗亞

Maria

麦甘

Megan

米莎爾

Michelle

米爾德麗德

Mildred

南希

Nancy

奧爾加

Olga

帕美拉

Pamela

羅斯瑪麗
Rosemary

露絲
Ruth

桑德拉
Sandra

薩拉
Sarah

莎龍
Sharon

舍莉
Shirley

斯苔芬妮
Stephanie

蘇珊
Susan

塔尼婭
Tanya

弗吉妮亞
Virginia

費雯
Vivian

佐伊
Zoe

MALE NAMES

安德魯
Andrew

亞當
Adam

阿倫
Alan

阿伯特
Albert

奧斯丁
Austin

貝克
Baker

本傑明
Benjamin

比爾
Bill

布蘭頓
Brandon

布萊恩
Brian

查爾斯
Charles

邱吉爾
Churchill

克里斯托弗
Christopher

科恩
Cohen

丹尼爾
Daniel

戴維
David

狄龍
Dillon

唐納德
Donald

伊頓
Eaton

愛迪生
Edison

愛德華
Edward

弗格森
Ferguson

福特
Ford

弗朗克
Frank

加里
Gary

喬治
George

吉布森
Gibson

蓋伊
Guy

哈里
Harry

亨利
Henry

伊恩
Ian

詹姆斯
James

傑森
Jason

約翰
John

約瑟夫
Joseph

喬舒亞

Joshua

賈斯廷

Justin

肯

Ken

盧克

Luke

馬克

Mark

馬修

Matthew

邁克

Michael

尼考拉斯

Nicholas

歐文

Owen

彼得

Peter

里查德

Richard

羅伯特

Robert

史蒂文

Steven

托馬斯

Thomas

泰勒

Tyler

威廉

William

p o e m s , p r o v e r b s ,
a n d p h r a s e s

On the following pages you will find examples of calligraphy to inspire you which you can re-create as gifts for loved ones, or even for yourself. These classic phrases and sentiments are accompanied by translations, and cover philosophical mottoes, tender messages of hope, and pithy words of wisdom, so there will be a thought to fit every occasion. All the poems, proverbs, and phrases are suitable to use in the projects throughout the book; the longer phrases are particularly suitable for using on fans and as talismans. You could personalize the phrase with one of the names featured on pages 114–120.

Choose a poem, phrase or proverb that particularly appeals to you, or that is relevant to an area of your life, such as a motivational poem for your work place, or perhaps a calming proverb to help you unwind at the end of the day. If you are prone to working too hard, why not keep a proverb near you to remind you that your time is precious? Sending a greeting to a loved one could include the simple proverb "All of us in the world are brothers", or move to a more poetic, spiritual sentiment such as the journeying poem "The road stretches up a long way ahead..." for a partner (see page 123).

Calligraphy, along with painting and poetry, is one of the Three Perfections, considered in China, and throughout the East to be the highest forms of art. Recreating these poems in calligraphy combines two of these art forms, and you could decorate your work with motifs, such as the leaves and flowers shown on page 112 or the bamboo and pine shown on page 71 to complete the historic partnership. As you work with the characters below, take time to consider the meaning of what you are forming; this will increase the enjoyment and sense of wellbeing you experience, and allow the act of calligraphy to create a meditative time for you.

Achieving a goal
When you have finally reached the highest peak,
All other mountains beneath your gaze are
 suddenly small.

Studying hard
If you have read tens of thousands of books,
The spirit of learning will flow from your brush
As you write.

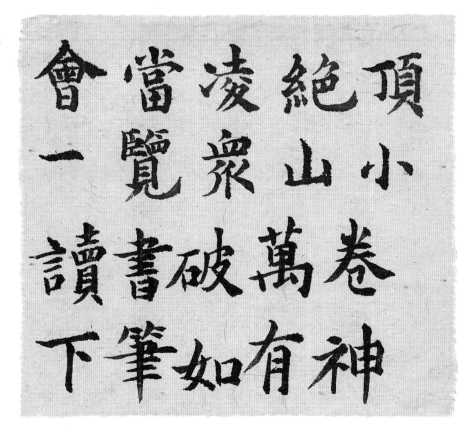

Greetings

... As contented and happy as the journey of a carefree cloud across a summer sky...

Staying calm

When you keep your position lofty, and take time to consider the dangers of failure, then you have found the way to avoid misfortune and find inner peace.

Greetings

The dragon and phoenix will bring you fortune.

Wishes for happiness

Everything on earth shines in the light
Thousands of mountain peaks offer up their
beauty.

For relaxation

As the fresh breeze floats still in clear night air
In the East the moon glides up above the
mountain peak.

For inner peace

When the glow of the sunset spreads over
all the sky
The golden sky and pure green mountains
Illuminate each other.

樂 其 遊 雲
隆 思 高 居
安 而 禍 克
祥 呈 鳳 龍
暉 交 物 萬 視
嶸 峰 仞 千 觀
動 徐 風 清
山 東 起 月
日 蔽 霞 雲
暉 相 碧 金

Friendship

All of us in the world are brothers, even the man who comes past as a traveler.

四海皆兄弟
誰為行路人

Friendship

The road stretches up a long way ahead. Let me go ahead and explore the hills and valleys of this world.

路漫漫其修遠兮
吾將上下而求索

For tenacity

The old horse lowers his head and pulls the wagon slowly forward. His ambition is to journey a thousand miles.

老驥伏櫪
志在千里

For hope

The wild fire of the forest will never burn out the grass of the fields.
When the wind blows in spring, the shoots will rise again.

野火燒不盡
春風吹又生

Refreshing the spirit

Following the flight of the wild crane, my heart flies far from this dusty earth.

心同野鶴與塵遠

Easing heartbreak

The silkworm spins silk until the day she dies.
The candle will burn down; in the meantime, tears have dried.

春蠶到死絲方盡
蠟炬成灰淚始乾

Seizing the day (for lovers)
Pick the blossom as it blooms; if you wait, you
can only have the branch.

For hope
Alone in the night I listen to raindrops splash
 against the wall of my little villa
I know next morning deep in the alley a girl will
 stand
Selling apricot blossom.

For self-realization
I do not listen to others when they tell me how
beautiful I am. All I want is to spread my spirit in
the world, fulfilling all around it.

In Spring
Thousands of blossom petals fall from the air
 around the grass.
A small boat stands by the shore, ready to carry
 the advent of spring to the opposite shore.

For enjoying the simple life
I am drawing out a long straight pole of bamboo.
I will take it to the river and use it as a fishing
rod.

花開堪折直須折
莫待無花空折枝
小樓一夜聽春雨
深巷明朝賣杏花
不要人誇好顏色
只留清氣滿乾坤
萬點落花舟一葉
載將春色到江南
寫取一枝清瘦竹
秋風江上作漁竿

For peace

The reds and golds of the sunset splash over
 the earth like a tidal wave.
In the distance the Cheng River flows still as silk.

餘霞散成綺
澄江靜如練

In Autumn

The land lies broad
The shore is clean
The sky rises high
The moon shines bright.

野曠沙岸淨
天高秋月明

Greetings

As they soar away, I bid the wild geese farewell
with my eyes; my fingers rest on the strings of
the lute.

目送歸鴻
手揮五弦

Friendship

You and I are the closest friends in the world.
Wherever we may be, even on opposite sides of
the earth, we will always be together.

海內存知己
天涯若比鄰

Achieving an ambition

I believe that soon I shall ride a breaking wave
and fly against the strong wind; on that day I will
hang a sail against wind and rain that will save
the world.

長風破浪會有時
直掛雲帆濟滄海

To open your mind

To see further, stand higher.

欲窮千里目
更上一層樓

Proverb

When you know you have made a mistake, do all you can to reverse it.

Proverb

When you've got something special, never forget it.

Proverb

Do not indulge in gossip about the weak points of others.

Proverb

Never rely on your superiority over others.

Proverb

A meal of jade is not necessarily something to be treasured.

Proverb

A stitch in time saves nine.

Proverb

A fine beginning is a beautiful thing.

Proverb

Always take most care at the end of your work.

Proverb

Center your heart, and cultivate your spirit.

Proverb

The rules of existence are all governed by a single harmony: the Way of the great Dao cannot be described.

知 過 必 改
得 能 莫 忘
罔 談 彼 短
靡 恃 己 長
尺 璧 非 寶
寸 陰 是 競
篤 初 誠 美
慎 終 宜 令
正 心 養 神
萬 物 同 性
大 道 無 名

index

acknowledgments

The author and publishers would like to thank their dear friends Flora Drew
and Ma Jian, without whose kindness this book would never have
come about.

The author would particularly like to thank Veronica Ashcroft, whose untiring
attention to detail and expertise are much appreciated, and Caroline and Tao
Tao for their support.